D1301548

DYNAMIC COMPOSITION

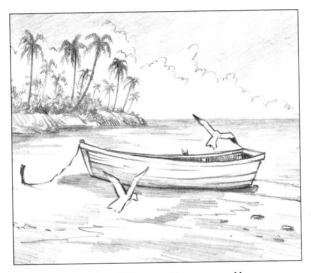

By William F. Powell

Walter Foster Publishing, Inc.
23062 La Cadena Drive
Laguna Hills, CA 92653
www.walterfoster.com

CONTENTS

INTRODUCTION

The study of composition is important for every aspiring artist. Although some artists say, "Just let it happen, and it will," creating dynamic compositions involves the careful selection of subject matter and placement of elements within the area on which we have chosen to draw (called the "picture plane"). When we decide to make a drawing, we have to ask ourselves some questions: What should this picture say? What is its purpose? What should be included to make my message clear to the viewer? Often we look at a drawing and feel that something about it is not quite right. Although the drawing might look fine for the most part and make proper use of many artistic principles, viewing it is uncomfortable. It does not hold our attention, so we move to the next work of art, looking for a more pleasurable experience and a more interesting composition.

Every picture begins with a simple idea. The final drawing may illustrate that simple idea, or it might grow into an energetic and powerful work—a dynamic composition. To achieve that dynamic quality, we must plan our drawings carefully and apply good compositional principles throughout the process. To begin each drawing, we determine the subject and message we want to convey, and then select the primary elements or objects we wish to accent and decide which elements are of secondary importance. Feel free to use "artistic license" to relocate, eliminate, or alter the position, shape, size, and value of any elements to improve the composition. Try not to simply "fill space"; unnecessary elements in your picture will only add clutter and confusion. With thoughtful planning, your dynamic compositions will satisfy the viewer's sense of interest, order, and beauty, while providing a rewarding experience for you.

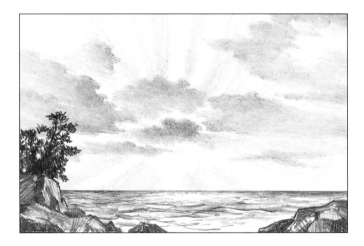

CHOOSING A VIEWPOINT

After we have selected a subject for our composition, we need to begin considering *viewpoint*—the position from which we observe and portray our subject. The viewpoint incorporates the *angle of view* (from which direction—right, left, or centered—we observe the subject) and the *elevation of view* (how high or low our position is when viewing the subject). Once these basics have been determined and our composition is finalized, our viewpoint cannot change throughout the drawing process. We must view the subject and all other related elements from the same position at which we started. Objects and structures change greatly, as does the entire composition, if we move from one angle of view or elevation to another.

Angle of View

The viewpoint extends from our eye to the horizon and includes everything we see from a selected, set position. If we move right or left, changing our angle of view, dramatic changes take place in the way we perceive and record the objects and the overall scene. When you are setting up a composition for a drawing, survey your subject from all angles to find the view that will enhance it best. Consider the surrounding elements that you believe will most dynamically highlight the subject. Once these decisions are made, begin refining your composition.

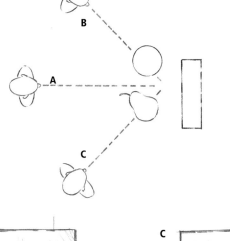

Changing Angle of View At right is an overhead view of an artist looking at a still life composition—a can , a box and a pear—from directly in front of it (A). The dotted lines represent the line of sight. As the artist moves to his left (B) and right (C) to achieve different angles of view, the appearance of the composition changes, as seen in the three illustrations below.

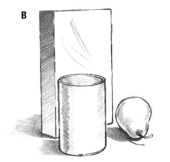
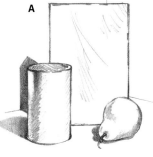
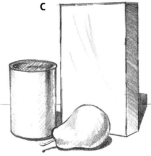

How the Angle of View Affects the Composition From the A position in the diagram above right, the artist sees the composition as it appears in the thumbnail sketch A, shown here. When the artist moves from that angle of view to points B or C, the composition changes as seen here in the left and right sketches; notice the differences in how all the objects appear and relate to one another in these three sketches. Also observe the change in the composition as a whole. Shifting your angle of view changes virtually everything in the composition; thumbnail sketches like these can help you see the differences in your own compositions.

Elevation of View

The elevation of view can be high, level (straight on), or low. From a high angle of view, we look down on the object and see the top and front; in this case, the object's placement on the picture plane is above the horizontal center. In a straight-on view, we see only the front of the object; its position is at eye level, near the middle of the picture plane. But from a low angle of view, we see the bottom and front of the object; its location on the picture plane is below the center.

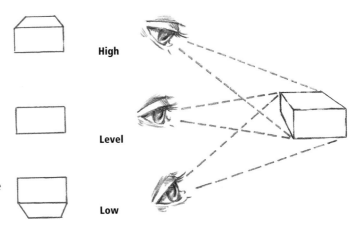

High

Level

Low

Changing Elevation of View High, level, and low elevation views of the same simple box result in three very different depictions of the subject (shown at the left side of the diagram).

Selecting the Right Elevation

Choosing the correct elevation of view for the subject greatly affects the composition of our drawing. When we view an object from above or below, it looks much different than it does from a level view. The choice of elevation can emphasize the structure of the subject and make a definite statement. For example, a low elevation view of an ocean sunset will emphasize the sky and the sun's rays across it; a high elevation view will highlight the water and the reflections of the sunset; and a level view will result in more equal sky and water elements. Experiment with sketching different subjects from various viewpoints. For each composition, decide which elevation portrays your subject in the most harmonious way. (See examples on the next two pages.)

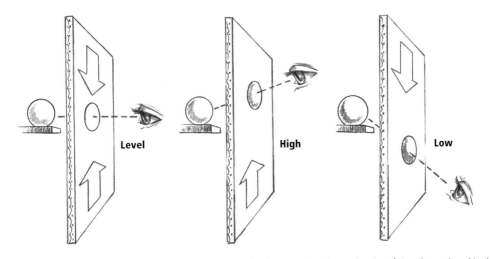

Level

High

Low

Elevation of View on the Picture Plane These illustrations show how variations in our elevation of view change the subject's position on the picture plane.

Comparing Elevations

On this page, we see the same scene from three elevations: high, level, and low. Elevation can dramatically change any subject: landscape, seascape, still life, or portrait.

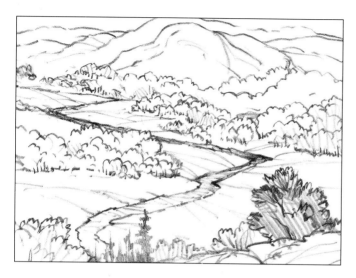

◄ **High Elevation** From a high view, we look down on the entire scene and see many different elements. We see almost no sky; an even higher elevation will totally eliminate the sky, making the landmass appear flatter and giving the river less perspective depth.

► **Level Elevation** In this straight-on (level) view, the length of the river is shortened and flattened. The trees are in a very natural position—the view is just a bit higher than our normal, eye-level view—and we see more sky. The bends of the river become more angular as they recede into the composition. Objects begin to show more size variation due to their placement on the picture plane and relationships with other elements. Distant objects become smaller, as does the width of the river. The top of the mountain almost touches the top of the picture plane.

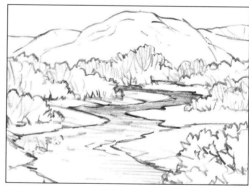

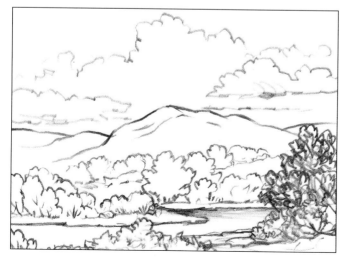

◄ **Low Elevation** This elevation is slightly lower than eye level, but it is very comfortable to view. There is more of a natural balance here than in the high or level elevations. Make certain that the highest point of the subject is either above or slightly below the true center of the picture plane to avoid monotonous symmetry. The mountaintop here, for instance, appears slightly above the center, considerably lower than in the other views, and we see a great deal of the sky. The low view flattens the river, and the overlapping trees create the illusion of depth in the composition.

Extreme Elevations

For a dramatic effect, try viewing everyday objects from an extremely high viewpoint—a "bird's-eye" view—or a very low elevation—a "worm's-eye" view. Even common subjects look very important from these exaggerated elevations. Try sketching from extreme elevations using small objects, and see how each changes in shape and presentation.

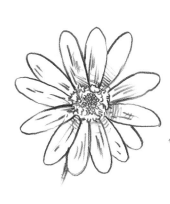

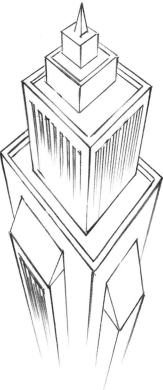

▶ **Seeing from a Bird's-Eye View** This view is even higher than a high-elevation viewpoint, showing the drama of looking down on an object. When looking down on a skyscraper, tremendous change occurs in the building's width; it becomes smaller as it recedes toward the lower floors. The largest portion is the part that is closest to us. If we were directly over the building, we would see none of the sides, only the top portions of each level; for that reason, a slightly angled view best depicts the dramatic qualities. The drawing of the daisy shows a bird's-eye view of a smaller subject. Here we are closer to viewing it straight down and consequently see only a small piece of the stem beneath the flower.

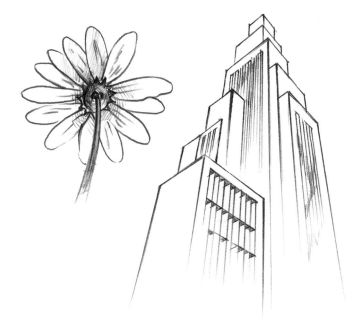

◀ **Seeing From a Worm's-Eye View** Here we have an opposite view of the building and the daisy. We are looking up, as if we were lying on the ground beneath the daisy or standing very close to the building. The worm's-eye view projects a feeling of towering strength to the subject. Notice that the top of the building and the stem on the daisy become smaller as they recede from our viewing point. The worm's-eye view can be just as dramatic in composition planning as the bird's-eye view.

CHOOSING A FORMAT

The two most common formats are vertical (also called "portrait") and horizontal (known as "landscape"), but artists use everything from squares, ovals, and circles to free-form shapes to showcase their drawings. Although some formats are best suited for certain subjects—and vice versa—nearly any format can be used for any subject as long as the drawing is composed correctly. Make simple, small sketches (called "thumbnails") of your subject using different formats; then select the one that makes the best presentation.

▲ **Portrait Format** Although this vertical format is called "portrait," it also is a wonderful shape for presenting cloud scenes and skyscapes—notice the low angle of view with large sky areas and just enough foreground to support the sky.

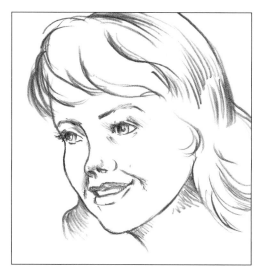

◄ **Square Format** A portrait of a person can be presented in many formats but the vertical or square formats are best. They allow us to focus the attention on the details of the face.

◄ **Landscape Format**
A horizontal format provides the width needed for the sweeping panorama of a seascape or landscape. However, it can be just as appropriate for a drawing of your favorite car, flowers, or any subject if the elements are thoughtfully placed

Circular and Oval Formats

Diversify your formats by using circular and oval-shaped formats to showcase subjects in a non-traditional manner. The most important consideration in successfully using these precisely curved picture planes is a good, balanced composition. With the right composition, these formats can accommodate almost any subject. Use a drawing template, computer image, or hand-drawn circle or oval as a picture plane, testing different shapes before selecting one for your composition. Ovals can be used either vertically or horizontally. Although round compositions are very pleasing to the eye, they are a bit more challenging than most other views. Balance and harmony of the elements should be very carefully considered; plan out the placement of your subjects in a sketch to create a feeling of unity in the overall composition.

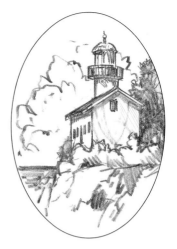

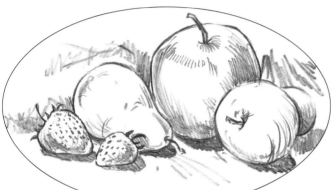

Using Ovals Whether horizontal (as in the still life at left) or vertical (as in the lighthouse drawing above), oval compositions immediately draw the viewer's eye to the subject. Each piece of fruit was chosen carefully to fit within the oval, and all the extraneous sky and land were designed to support the lighthouse.

Circular Drawings A composition with vertical lines, angles, and opposing lines works very well in a circular format, as shown at right. The diagonal lines of the foreground tree limbs, the angle of the stream, and the verticals of the background trees contrast the circle of the picture plane, creating visual interest.

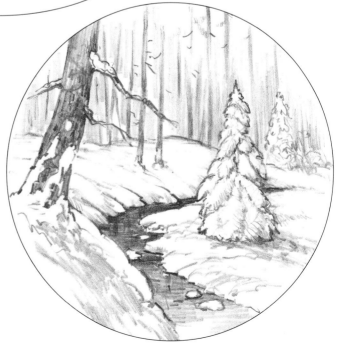

Unique Formats

It is challenging and fun to plan a composition to fit a format that is out of the ordinary, such as the two-part diptych, the three-paneled triptych, the wide panorama, and other extreme-view or unusual formats. The subject of a paneled format must flow smoothly from one panel to another, while maintaining the ability of each panel to stand alone as its own composition. Formats that are either very wide or very tall can accommodate subjects with those special characteristics. And free-form shapes with flowing curves can produce a fluid feeling, leading the eye around a composition. As a practice exercise, select a subject that interests you and create a composition within an unusually shaped format.

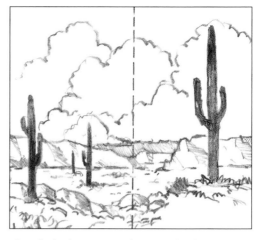

Diptych This desert scene can be separated at the dotted line, but the size and placement of the cacti bring the elements together to also function as one composition.

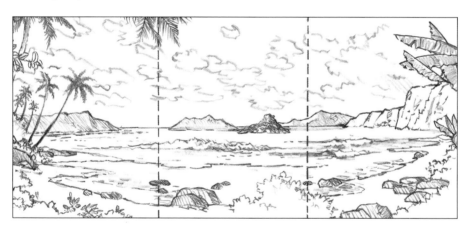

Triptych The foliage on the sides and bottom of this composition provides a scooping frame for the overall design, but each panel of the triptych could stand alone compositionally. Cover any two panels to test this.

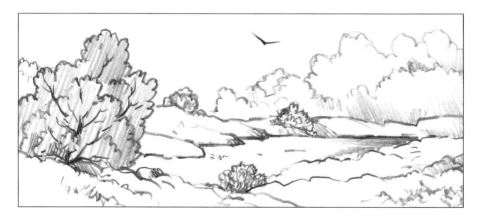

Panorama The bushes on the left side of this panoramic drawing are balanced by the clouds on the right. The bird is slightly off center and acts as a point of interest, bridging the elements on either side and encouraging eye movement.

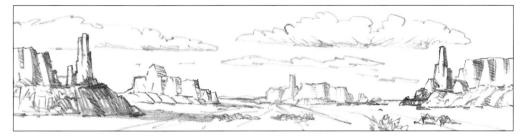

▲ **Extreme Horizontal Format** The long, horizontal picture plane above allows us to compose a balanced view of the expansive desert. The vastness of the scene spreading across the exaggerated format seems to surround the viewer.

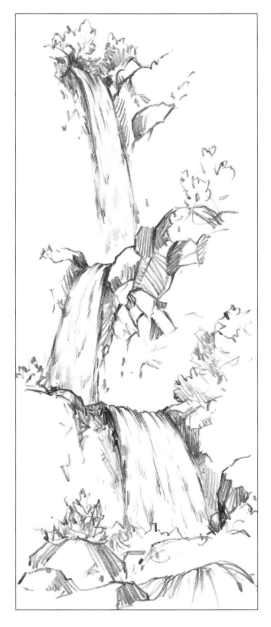

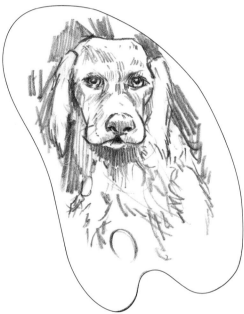

▲ **Irregular Format** This sketch of a dog on an organically shaped artist's palette creates an interesting and unexpected presentation, which echoes the shape of the animal's head while reflecting the owner's love of art and the pet.

◀ **Extreme Vertical Format** The waterfall at left has plenty of room to cascade down the tall, narrow picture plane and flow out toward the viewer at the bottom. The surrounding plants and rocks follow the line of the waterfall to heighten the dynamic force of the moving water.

11

BASIC COMPOSITION METHODS

A successful composition directs the viewer's eye through the drawing, emphasizing the center of interest, or "focal point." Although many factors are involved in creating an effective composition, the way in which you arrange the elements within the drawing is key. We use *value* (lights and darks), *depth* (the illusion of distance or a three-dimensional quality), and *line* (the direction or path the eye follows) to create a natural movement and flow of the elements. There are several basic techniques you can use to achieve an interesting composition; some are based on letters of the alphabet and others are based on forms, shapes, or lines. The diagrams and drawings here illustrate some of these methods.

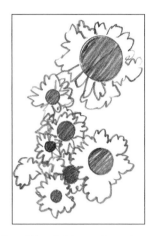

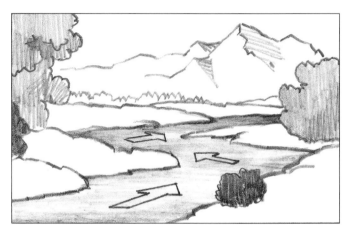

Repetition In this example, one type of flower is repeated in different sizes, which are strategically overlapped to create the composition. The repetition leads the viewer's eye from one flower to the next, largest to smallest and back again, producing smooth eye flow and rhythmic movement throughout the picture plane.

S Shape This composition uses a flattened S shape in the river to lead the viewer into the scene (see arrows). The large tree mass on the left balances the distant mountain and the smaller foliage at the right, pushing the viewer's eye back to the center. At the same time, depth is achieved by varying the light and dark objects in the scene, diminishing the size of distant objects, and using lines delineating the stream that get closer together as they get farther away.

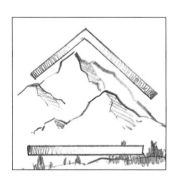

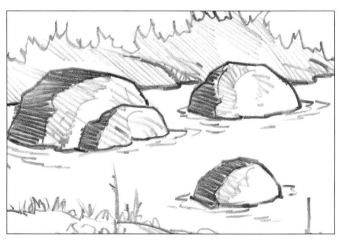

Contrasting Angles and Lines This sketch shows the use of the dramatic, rugged angles of the mountains in contrast with the long, horizontal lines of the ground, which give viewers a calm resting place before their gaze returns to the angular mountains.

Three-Spot Design This common design places three elements in a picture plane in a triangular arrangement to create balance and harmony within the entire scene. Odd numbers keep our eye from pairing off elements and also generate interest. Secondary rocks, shrubs, and water act as supporting elements to the focal rocks.

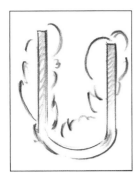

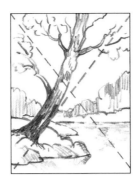

U Shape This shape often is applied as a guide to creating a balanced composition; the curve moves the eye from one side to the other. The U can be distorted by varying the length of the "legs" to achieve a more dynamic effect, as shown here in the foliage height.

X Shape Here an X is used as the composition guide for a dramatic scene in which the tree almost seems to be falling. The trunk and limbs of the tree form most of the X shape, and the triangle formed by the lake completes it. Other angles echo the basic X design.

Curved Forms Curved lines are soft and calming. Here the curved forms of the clouds are repeated on the ground as trees or bushes with a similar shape. Diagonal and horizontal lines in the middle ground support and contrast the curved forms, adding interest.

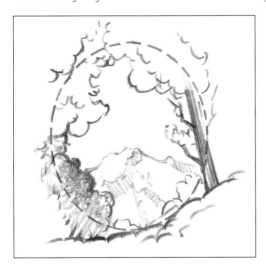

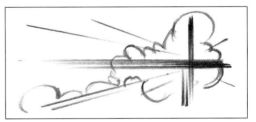

▲ **Cross Shape** The use of a cross shape draws the viewer's attention to the point where the cross members meet, pulling the eye toward the focal point. The cross shape is stable and creates a powerful composition featuring light, as shown here.

◀ **O Shape** To draw the viewer's eye to the center of a composition, place elements around the area in an O shape. Bushes, trees, and foreground foliage are used to form this O, which features the view of the distant mountain.

Opposition The sketch on the left uses opposing lines to focus on a point. In the center, a fluid up-and-down movement is achieved by using curved lines to direct the eye. The intersecting lines of the L on the right are formed by the open ground and the tree. When using an L, be careful not to create a scene that is too heavy on one side; balance it with elements on the opposite side.

THE GOLDEN MEAN

The composition of most classical art is based on the Golden Mean, also known as the Golden Ratio, Golden Section, or the Divine Proportion. In ancient Egypt and Greece, design used a constant factor in a geometric progression, and that ratio was first calculated by a mathematician known as Fibonacci in the 13th century. The Golden Mean, or 1.618, is the constant factor in his continued proportion series: 1, 1, 2, 3, 5, 8, 21, 34, 55, 89, 144, and so on. By adding the last number to the previous number, we arrive at the next number in the series; for example, 21 + 34 = 55, 55 + 34 = 89, and so on. By dividing any number by the previous, we get a result close to 1.618. In a continued proportion, the closest pair of numbers to the Golden Mean of 1.618 is 55 and 89—these two numbers are used most frequently in fine design to establish proportionate space.

Finding the Golden Mean in Nature

Examples of the Golden Mean are all around us in nature: the structure of sea shells, leaf and petal groupings, pinecones, pineapples, and sunflowers, for instance. Several examples are illustrated in the photos on this page. On the following pages, we will work with methods of using the Golden Mean ratio as an organizational tool to determine the optimum size and division of our picture planes.

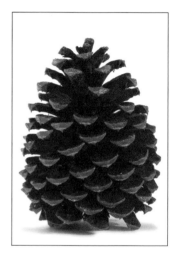

▶ **Naturally Occurring Ratio** The Golden Mean ratio and spiral pattern also can be seen in the structure of most pinecones. Note how the individual pieces spiral up from the bottom of the cone. There actually are two spiral patterns: one to the left and one to the right. Different types of conifers generate different spiral patterns. The pineapple spirals in this same manner.

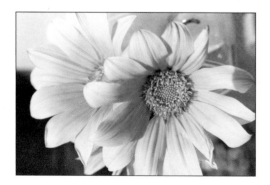

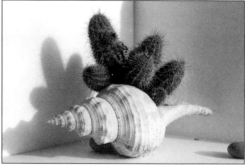

The "Perfect" Ratio of 89:55 The center of the daisy, like the sunflower and other plants with large seed heads, shows the geometric pattern formed by the Golden Ratio. As the seeds or pistils move out from the center of the flower, they create spiral patterns that curve to the right and left at an 89:55 ratio.

Constant or Geometric Spiral The conch shell shown here demonstrates the Golden Mean—as each section of the spiral naturally increases in size by 1.618 as it moves outward. This is called the "constant spiral" or "geometrical spiral."

Measuring in Units	The Golden Mean is commonly measured in units based on the perfect ratio. Therefore, as shown in Method 1 on page 15, 2.47 cm would equal 89 units, and 1.53 would equal 55 units (for a total of 144 units).

Finding the Golden Mean of a Line

The 1:1.618 ratio is used by designers and artists in all media, such as architects, engineers, cabinet makers, and many other creative people. In this exercise, we concentrate on dividing a line into what is commonly accepted as the most aesthetic division.

You can find the Golden Mean of any line by measuring it and using a calculator to divide that number by 1.618 (Method 1). Mark a point at that measurement on the line to divide it into two segments of the perfect proportions. You can continue to divide each smaller section of the line by 1.618 to create more divisions in the Golden Mean ratio. You also can use simple geometry to achieve the same results that the Greeks used in their design (Method 2). Just follow the steps below that illustrate each method.

Method 1: Calculator

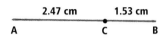

Step One Begin by drawing a line of any length and label the two endpoints as A and B. This particular line is 4 cm long.

Step Two Divide the length (4 cm) by 1.618. The number you get (in this case, 2.47 cm) is the distance between A and C above.

Method 2: Geometry

Step One Begin by drawing a line of any length and label the two endpoints as A and B. Divide the line length in half and mark the center point.

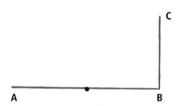

Step Two Draw a perpendicular line at point B that is equal in length to half of line AB (the measurement from the center point to A or B). Label the end of the new line point C (BC = 1/2 AB).

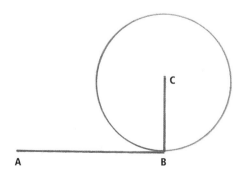

Step Three Draw a circle with the center at point C and BC as the radius.

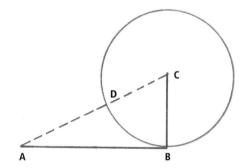

Step Four Draw a line from A to C. Label the point where line AC passes through the circle as point D.

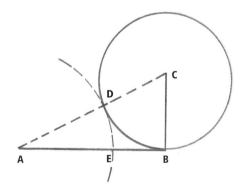

Step Five Using point A as the center and AD as the radius, draw a partial circle which intersects line AB; that intersection is at point E (EA = AD). You should find that line AE equals a division of 144/89 and line EB equals a division of 89/55, where 144 is the original line length (AB). Contrast is created by the differing sizes of lines AE and EB, and unity is created by the correlation of line EB to the entire line AB (the Golden Mean).

Creating a Golden Mean Rectangle

The square and the rectangle are two of the most important picture planes for two-dimensional art compositions. Infinite numbers of width and length combinations for these areas exist, but none are more pleasing to the eye and aesthetically proportioned than the Golden Mean rectangle. This rectangle is based upon the same ancient rules of aesthetic proportion used by the Greeks in their art and architecture. There are several approaches to creating a rectangle that conforms to the Golden Mean proportions. The following is one method explained in four simple steps.

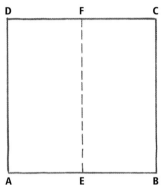

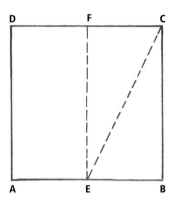

Step One Draw a perfect square (ABCD), which will serve as the base for all measurements when creating your Golden Mean rectangle. The length of AD should be the length you want for the short side of your rectangle when it is finished. Divide AB in half to find E, and divide DC in half to find F; then draw a vertical center line (EF) through the square.

Step Two Next draw a line from point E (the halfway mark on the line AB) on a diagonal up to the right corner of the square (C). This line (EC) becomes the basis for the length of the rectangle extension. Set your drawing compass to the length of EC as its radius or measure the length with your ruler.

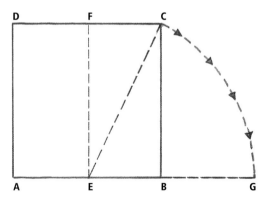

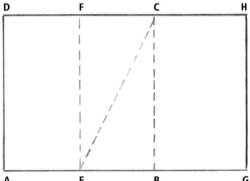

Step Three Use the compass or ruler to drop the diagonal line (EC) down until it becomes horizontal, on the same line with A, E, and B. Line EG = EC and BG is the extension length which will create the Golden Mean rectangle. The sides of the rectangle (AD and AG) are in proportion at the 1:1.618 ratio.

Step Four Draw lines to complete the rectangle, from B to G, G to H, and C to H. Notice the "ghost" lines that indicate the steps taken to construct a true Golden Mean rectangle. The ratios of 55:89 and 1:1.618 apply to the areas of the original square as compared to the complete rectangle.

Spiral Patterns in Compositions

Down through the centuries, scientists and artists alike have employed the Golden Mean in their work. Leonardo da Vinci used the Golden Mean extensively in his drawings and inventions. Archimedes—a mathematician, engineer, and inventor who lived in ancient Greece—is famous for his work in physics, which involves focusing on circles, spheres, and cylinders. His theories of spirals are based on a plane curve moving away from or toward a center point at a constant rate. By definition, a two-dimensional *spiral* is a line winding around a center point while continuously moving away from or toward it.

Using Archimedes' principles, the Golden Mean rectangle created on the previous page can be further divided, and a natural spiral can be created within it, using curves drawn on the radius of the square within the rectangle (see instructions below). If you rotate your paper 1/4 turn counter-clockwise each time you draw a curve, you easily can see where to work next. Always divide the new, rectangular section of the Golden Mean rectangle using the length of the shorter side of the new section to mark off the square in that section and drawing a new quarter circle within it. Each curved line is drawn with the radius of the square it is in and connects to the one before it to form the spiral.

There are a variety of spiral patterns in nature, and many of them fall into the pattern of an Archimedean spiral (see page 14 for examples). To create the gentle spiral we see in the conch shell, follow the instructions below.

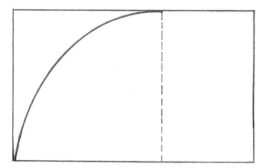

Step One Draw a Golden Mean rectangle as we did on the previous page. Erase the extra lines but not the side of the square (BC). Next, draw a 1/4-circle curve in the square with the length of the side as its radius and positioned as shown above.

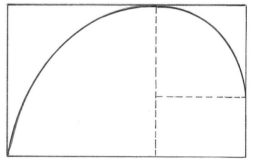

Step Two Divide the smaller portion of the rectangle (on the right) into another Golden Mean proportion, drawing a square within it using the length of the shorter side of the rectangle as the length of the sides of the square. Continue the curve as shown.

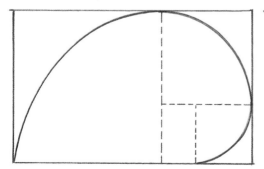

Step Three Divide the smaller portion of that rectangle into another Golden Mean proportion. Draw a second square using the shorter side of the rectangle as the length for the sides of the square. Continue the curve with the new radius, as shown.

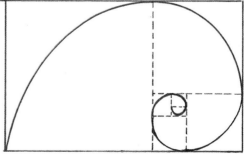

Step Four Continue dividing each smaller rectangular proportion and drawing the gentle curve in the square as before. This progression can be repeated until you have reached the immediate center point from which the curve originates, if desired.

DIVIDING THE PICTURE PLANE

In addition to the Golden Mean, many other methods can be used to divide the picture plane into a pleasing and balanced composition and help with the placement of elements. The *rule of thirds,* for instance, is accomplished by drawing lines that divide the picture plane into thirds, both vertically and horizontally, to form a grid that is used as a guide for placing elements. Some artists call it a simplified Golden Mean rectangle, but it is not, because these thirds do not fall into the perfect ratio of 1:1.618.

Once you have the grid of thirds established on the picture plane, it can be further divided within itself to create even more complexity in the composition. The intersections of the grid lines are excellent points for placing objects (rather than drawing them in the direct center of that space). Other methods of dividing the plane use diagonals and right angles; some methods are illustrated here in the small, thumbnail diagrams with the larger drawings beside them. All of the examples are shown using a Golden Mean rectangle as the picture plane, but they also can be applied to other formats.

▶ **Basic Rule of Thirds** This diagram shows the basic rule-of-thirds division and object placement. The large, rounded vase in the drawing sits on the lower left grid point and the flowers in the vase sit on the upper left grid point. The two smaller flowers and the line of the drapery balance the composition with their corresponding placement at the right points of the grid; they also lead the viewer's eye back to the arrangement.

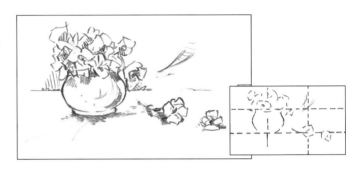

◀ **Thirds with One Diagonal** Here the rule of thirds is used with a diagonal. Grid lines divide the plane into three equal parts, vertically and horizontally. The pine tree is aligned on the left vertical with its trunk ending on the lower left grid point. The mountain peak falls on the upper right grid point, and a diagonal between the two assists in moving the viewer's eye down to the tree.

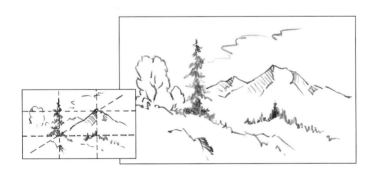

▶ **Thirds with Two Diagonals** The rule of thirds also can be applied by drawing a diagonal line from one corner to the other. Then lines at 90° to the diagonal extend to the corners. Horizontal and vertical grid lines can then be placed at the intersections of the lines. This forms a grid of thirds with a larger central area and also creates pathways for placing elements like the mountains and the tree line.

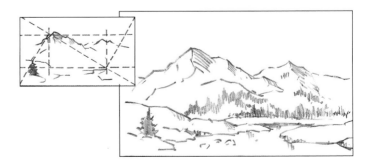

▶ **Horizontal Division** This simple method of division helps us avoid placing the horizon or any other important horizontal element directly on the center line of the picture plane. The scene is divided into three major parts: background, middle ground, and foreground. Elements in each of those areas—the birds, waves, foam, and rocks—contrast the primarily horizontal orientation of the scene.

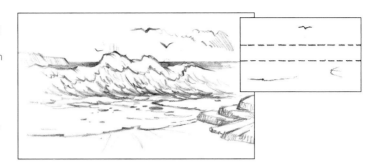

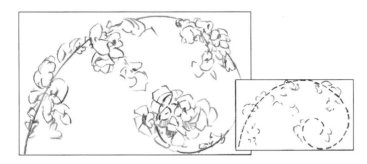

◀ **Golden Mean Spiral** Formed using the method on the previous page, the spiral created in a Golden Mean rectangle is a wonderful guide for graceful floral designs and even landscapes. This spiral can be rotated on the picture plane or reduced in size. If you wish, you can use only a portion of the spiral or combine a spiral with one of the other division methods.

▶ **Diagonal with Opposition** Simply draw a diagonal line across the picture plane; then draw a line at 90° to the diagonal extending to a corner, as shown. The focal point should be placed where the two lines meet. In this drawing, a weathered tree is placed there; the line of the middle-ground hills runs along the diagonal to lead the viewer's eye to the tree.

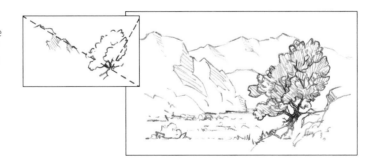

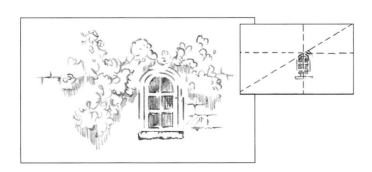

◀ **Off-Center Division** To place elements just slightly off center like this window and greenery, draw a vertical line in the area where you think the primary subject should be placed (avoiding the center of the paper). Then draw a diagonal line from corner to corner. Add a horizontal line where the first two lines cross. This line is a perfect guide for placing secondary elements, like the vines here.

USING LINES EFFECTIVELY

We use lines in our compositions to define areas and create details, but lines also serve many other purposes. Lines can lead the viewer's eye throughout the composition, define contrasts in value and texture of the elements, and set the mood of the composition. Practice drawing many different kinds of lines: straight, curved, broken, wavy, jagged, short, long, light, and dark. Draw them in varied thicknesses and random directions. The qualities of these lines can be used to your advantage in creating a dynamic composition. After sketching these lines, look for lines that express a variety of concepts, such as balance, confusion, calm, grace, support, lethargy, movement, rhythm, and stagnation. If you don't find lines that express those feelings, try making them.

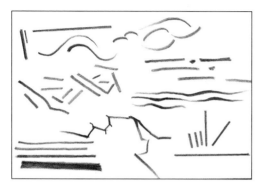

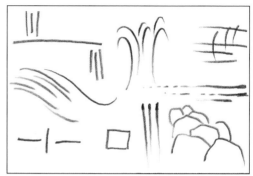

Line Quality Enriches Composition Carefully consider these lines to determine which convey qualities like softness, rigidity, anger, fragmentation, instability, and balance. All these lines can help to define the elements in your compositions.

Creating Movement We use different types of lines to create a flow in our compositions, leading the viewer's eye around the picture plane. Often this flow—or lack of it— is reflected in the way you actually move as you are drawing these lines.

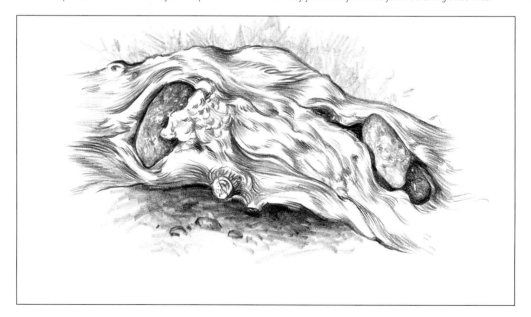

Featuring Lines in a Still Life The lines in this composition show the expression of many different linear qualities. The soft, undulating lines express movement very similar to the flowing water of the stream in which the log was found. The gnarled wood, which actually grew around the stones and partially covers the stone at left, is strong, with the curves "pushing" at the stone. The striated lines of the wood grain around the stones contain them, like stretched muscles. The lines in the background support the subject.

Lines for Composition and Subject Qualities

As you translate your practice lines into subjects, notice how they work together to create interest and flow in your composition. Here, the diagonal composition line guides the placement of the soft, snowy hillside; the straight trees have crisp lines. The viewer's eye moves down the hill, up the tree on the right, and back down through the foliage.

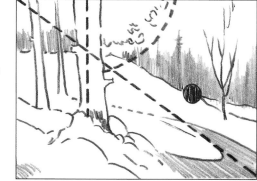

▶ **Step One** Begin this exercise by drawing light composition lines on the picture plane: the first is a corner-to-corner diagonal; then a vertical line one-third of the way in from the left side; then a curved line starting slightly above the horizontal center of the rectangle. Now you can place the elements using these lines as a guide. Draw the foreground trees with broad, straight lines which show strength and stability. Those strong verticals are repeated in the background trees, but they blend into each other because they are so distant. The broad open area on the right balances the weight of the trees on the left.

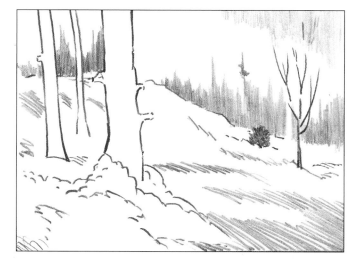

◀ **Step Two** Continue using lines to shade the background areas. Further emphasize the angle of the hillside with crisp, diagonal, shading lines on the snow, which also give it an icy, cold feeling. The small bush is a random collection of short, dark lines which make a bold contrast to the white snow. Use many unstructured, curved lines to define the snow beneath the trees; these soft mounds look unstable and temporary, as if they might slide down the hillside. The rhythmic placement of the foreground trees leads the viewer's eye down the hill as well. The lone, bare tree, with its branches flowing upward toward the sky, contrasts the rigid verticality of the other tree trunks.

▶ **Step Three** Using the side of your pencil, darken the most important elements and the background at the left to make the snow and tree trunks more prominent. Create the bark texture on the large tree with sharp, wide, vertical strokes, which attract the viewer's eye. Develop the foliage of the main tree using a wide-pointed pencil and short, multi-directional strokes; make these lines without lifting your pencil from the surface, but do change direction and pressure to create variation in the weight and value of the lines and give a powerful look to this hearty foliage. Even though there is a great deal of contrast in the lines of this composition, the overall effect is one of careful balance.

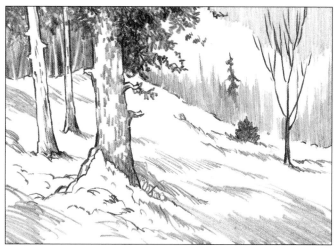

SYMMETRY AND ASYMMETRY

Symmetry is the balanced similarity of form on either side of a dividing line. *Asymmetry* is the lack of symmetry. Two common types of symmetry are bilateral and radial. *Bilateral* or *mirror* symmetry occurs when the right and left sides or top and bottom of an element or composition are counterparts to one another, such as our bodies, most fruit, and the letters A, B, and H. In *radial* symmetry, similar parts are evenly arranged around a central point, as in a starfish or snowflakes. Symmetry can apply to both geometric and natural patterns and shapes.

Symmetry and asymmetry in a composition can be seen in the individual elements and in their relationship to each other. Generally, asymmetry in compositions is more interesting than symmetry, which can be monotonous and fail to capture the viewer's interest. A combination of symmetry and asymmetry makes a composition compelling to the viewer.

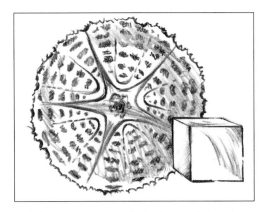

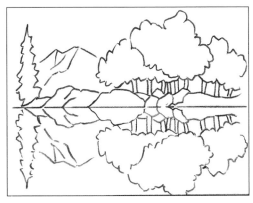

Radial Symmetry A sea urchin has five sets of plates that are arranged symmetrically around an axis at the base. A salt crystal is an example of three-dimensional symmetry with all the surfaces equidistant from the center.

Mirror Symmetry A landscape scene like this one can be "mirrored" or repeated upside down in still water. If there were movement on the water's surface, the reflection would be distorted and the composition would be less symmetrical.

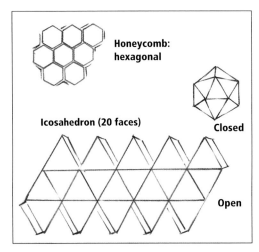

Geometrical Symmetry A honeycomb has a naturally precise hexagonal pattern of repeating symmetry. An icosahedron, carefully drawn with 20 triangular faces, is pictured open and closed to show its symmetry.

Non-Geometrical Symmetry The natural elements above have been used for centuries in basic design. Although not absolutely symmetrical, they suggest symmetry through repetition of shape and line and balance of weight.

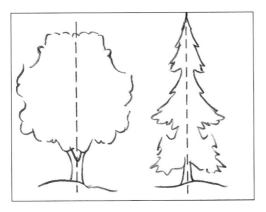

◄ **Bilateral Symmetry** These trees are exactly alike on both sides of the dividing line. Such shapes rarely occur in nature and present an unnatural look within a landscape composition. Precise symmetry is rarely used in successful compositions.

▶ **Bilateral Asymmetry** Here are the same two trees as shown above, but these have been drawn with slightly different sides. This asymmetry makes the trees appear more natural and realistic; our eye actually sees this as a more appealing image. This is a good example of appropriate use of asymmetry in a composition.

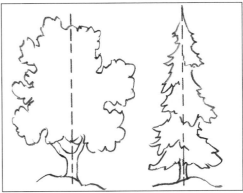

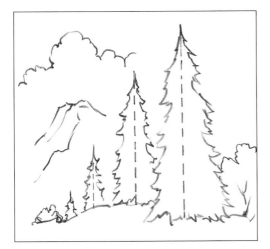

◄ **Symmetrical Placement** The basically symmetrical form and placement of the pine trees is dominant, balanced by the asymmetrical shapes of the broadleaf trees, mountain, and clouds. This composition shows the use of "translatory symmetry," an element repeated to direct the eye into the distance.

▶ **Asymmetrical Placement** The rounded asymmetry of the large, broadleaf tree in the foreground on the diagonal horizon line is dominant, balanced by the placement of the pines and the horizontal floating clouds. This composition is based on the "Contrasting Angles and Lines" method (see page 12).

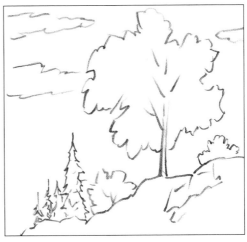

USING VALUES

Now that we have looked at methods for dividing the picture plane and considered the use of line and placement of the elements, we need to focus on the impact of value on our compositions. Values are the light to dark shadings in our drawings that give our compositions a lifelike depiction of depth. The viewer's eye is naturally drawn to areas of great contrast between values—where the darkest darks meet the lightest lights. We intentionally place values in our compositions to help direct the viewer's eye to the most important areas of our drawings. These values also can help set the mood of your composition. The three drawings here illustrate different ways you can use value as a compositional element.

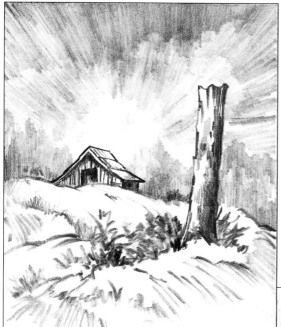

◄ **Directional Value Rendering** In this example, the values in this sunset sky range from the bright highlight of the setting sun to the dark sky behind the clouds. The background values of the sky are made with radiating strokes that seem to converge at one point in the middle ground, lightening in value as they near the center. This dramatic effect is built through lines of varying values that lead the viewer's eye to the barn. These lines are contrasted by middle-value, vertical strokes in the background trees. Note that all foreground shading and lines lead to the center of the composition for emphasis.

► **Minimal Use of Values** This scene uses dark values to make the leafless tree the focal point of the composition; other elements are in a narrow range of light to middle values, so they don't draw attention away from the tree. The direction of the clouds is established with middle-value lines that lead back to the ground. The middle ground and foreground are developed using limited range of values, again to keep the focus on the barren tree. The dark values of the foliage and the fence posts keep the eye circulating around the composition, but there isn't enough contrast to create any confusion about the focal point. By using minimal values and keeping the elements simple, you can make a powerful statement when creating a focal element.

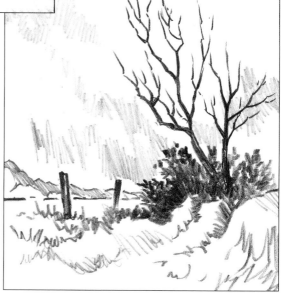

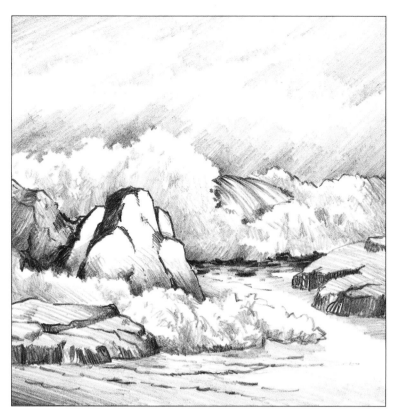

Maximum Value Range
This composition has three horizontal divisions: background; foreground; and middle ground, which shows the greatest range of values. The lightest values emphasize the most important elements—the middle-ground boulder and breaking wave; the light areas are contrasted with adjacent dark shading to draw the viewer's attention to these elements. The foam and water are shaded with smooth but lightly textured hatching (parallel lines) and crosshatching (overlapping sets of parallel lines at different angles). The edge of the wave where it strikes the rocks is emphasized by the shading beneath it. The diagonal shading of the sky balances the opposite action of the waves and movement of the water.

Value Sketch To render a drawing with a wide range of values, begin by developing a small value-pattern sketch like the one at left, which shows the main subjects and preliminary shading. As you see the areas develop in the sketch, you can move, lighten, or darken values to enhance the statement of the work. Then use this sketch as a guide for your final drawing, which will show more detail and a wider range of values.

CREATING A FOCAL POINT

A key element in creating a successful composition is including more than one area of interest, without generating confusion about the subject of the drawing. Compositions are often based on one large object, which is balanced by the grouping, placement, and values of smaller objects. Directing the viewer's eye with secondary focal points helps move the viewer through a scene, so that it can be enjoyed in its entirety.

The primary focal point should immediately capture the viewer's attention through size, line quality, value, placement on the picture plane, and the proximity of other points of interest which call attention to it. The secondary focal point is the area that the eye naturally moves to after seeing the primary focal point; usually this element is a smaller object or objects with less detail. Another secondary focal point may be at some distance from the viewer's eye, appearing much smaller, and showing only minor detailing, so that it occupies a much less important space in the drawing. This distant focal point serves to give the viewer's eye another stop on the journey around the composition before returning to the primary focal point.

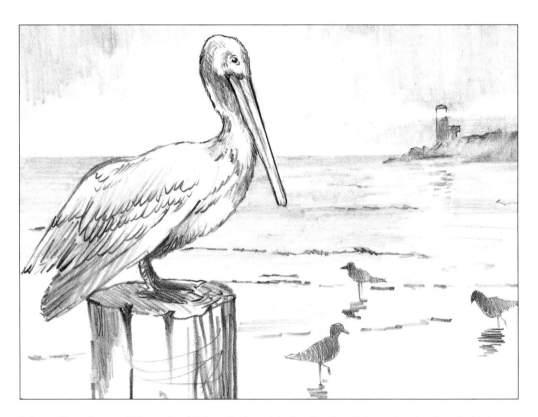

Primary, Secondary, and Distant Focal Points The size and detail on the pelican designates it as the primary focal point, and it immediately catches the viewer's eye. The pelican's gaze and the point of its bill shifts the attention to the small birds in the foreground (the secondary focal point). By keeping the texture and value changes subtle in the middle ground, the eye moves freely to this point. These three small birds are shaded fairly evenly so they don't detract from the primary focal point. The triangle created by the birds, along with the water's edge and the point of land, leads the viewer's eye to another, more distant focal point—the lighthouse. Here the two subtle rays of light against the shaded background suggest a visual path. The rays of light, the point of land, and the horizon line all work together to bring the viewer's eye back to the pelican, and the visual journey begins again.

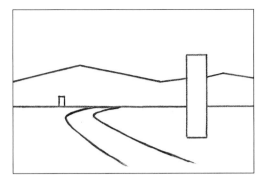

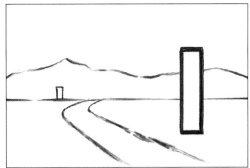

Lack of Focal Point When all lines in a composition are drawn with the same depth of intensity (value) and width, the entire design appears flat and uninteresting, with no focal point.

Focal Depth and Flow By simply changing the weight of the lines of the foreground rectangle, and by varying the quality of lines in the road and mountain, the scene has more focal interest.

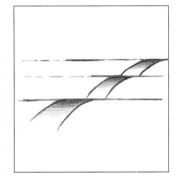

Focal Curve A graceful curve leads the eye into the composition. This can be used for roads and pathways to create the illusion of hills and valleys, and also in subjects like floral arrangements to direct the viewer's eye.

Focal Depth The focal curve is one way of creating depth in a composition; here it serves as a road in a natural setting, leading the viewer into the scene. The use of overlapping elements—the trees—also adds to the illusion, creating focal depth.

Multiple Focal Curves To further accentuate the feeling of distance, more than one curve can be used, along with multiple elevation lines. Notice that the curve segments are displaced and become smaller as they recede in the distance.

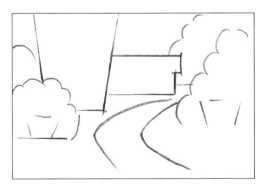

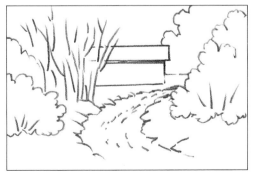

Sketching Focal Patterns Sketch a preliminary, simple pattern plan to show the general placement of elements without the distraction of internal details, value or line quality. Look for the focal pattern—how the eye moves around the picture and what is important—and adjust as needed.

Develop the Pattern After sketching and adjusting a preliminary pattern plan, lightly add details to build the feeling of rhythmic movement and depth. Begin varying the weight of the lines and refining the shapes of the elements. As you continue, use value to further accentuate the focal pattern.

FORMING AND PLACING ELEMENTS

The basic shapes used in creating visual art—the square, rectangle, circle, and triangle—are two-dimensional (2-D). The diagrams below show how to create the illusion of depth (three dimensions or 3-D) by extending each 2-D shape. These 3-D forms are combined and modified to form the elements we draw. For an effective composition, they must be overlapped on the picture plane to unify the elements and provide depth. At the same time, the arrangement must display balance in which the elements' size, placement, and value occupy the space to create a harmonious composition.

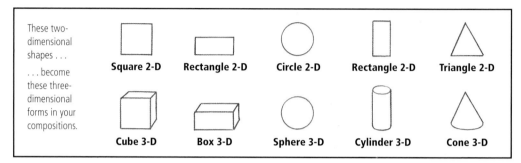

These two-dimensional shapes . . .

. . . become these three-dimensional forms in your compositions.

| Square 2-D | Rectangle 2-D | Circle 2-D | Rectangle 2-D | Triangle 2-D |
| Cube 3-D | Box 3-D | Sphere 3-D | Cylinder 3-D | Cone 3-D |

Arranging Elements in a Still Life

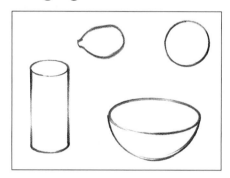

Turning Shape into Form Derived from basic shapes, these elements can be used in a still life composition. Cut a sphere in half for a bowl. A circle can become an orange; a cylinder, a can. Stretch a circle horizontally to create a lemonlike ellipse.

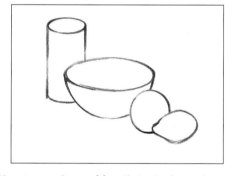

Monotonous Composition Placing the elements in a continuous line, as shown here, creates monotony and boredom. There is a slight sense of depth achieved by overlapping, but all the attention is focused on the last item, the vertical can.

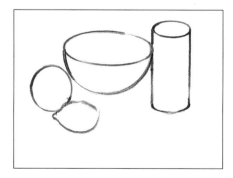

No Depth or Balance This C-shaped composition offers a slightly better placement, but when elements are just touching—not overlapping—nothing creates depth or balance.

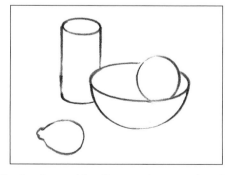

Pleasing Composition Here some elements overlap—the orange is placed in the bowl for further interest. The elements balance one another and hold the viewer's interest.

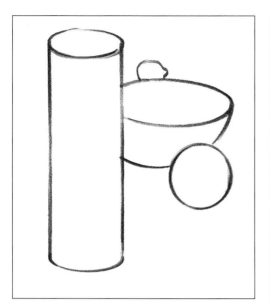

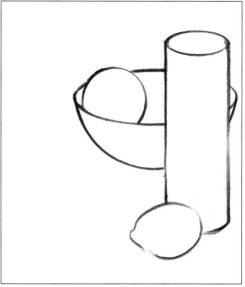

One Dominant Element This arrangement is fairly comfortable, even though the cylinder is quite dominant. If you wish to emphasize one major element, be sure that it is worthy of the attention and that the other elements support it. Overlapping the objects creates depth and supports the cylinder.

Unbalanced Placement Even though all these objects are overlapping and the orange is once again placed in the bowl for interest, the viewer is left with the feeling that everything is falling off the page. In addition, the side of the cylinder is at the center of the bowl, visually cutting the composition in half.

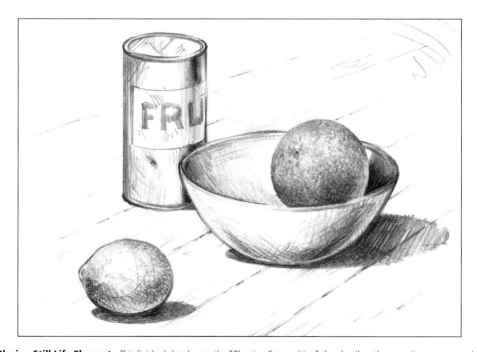

Placing Still Life Elements This finished sketch uses the "Pleasing Composition" thumbnail on the opposite page as a guide. The two-dimensional shapes of the thumbnail have been transformed into three-dimensional forms through shading to create highlights, shadows, textures, and a surface (the wooden table). The finished composition shows depth and dimension.

ARRANGING A FLORAL COMPOSITION

Few drawing subjects require more intensive composition than a floral arrangement, which is a work of art in its own right. Carefully consider balance, line, value, and form, and limit the number of flowers so each can be seen and appreciated. An even number of elements can make a very balanced floral composition, but avoid arranging the flowers so that they visually "pair up," as this stops the viewer's eye. For that reason, many artists prefer to group flowers in odd numbers or arrange them so that they form a triangle. Often the leaves become as important as the flowers themselves; limit the amount of greenery to allow the flowers to be the primary focal point. Likewise, the choice of vase or other container to hold the flowers should be complementary to the floral type: for example, an informal bunch of daisies might look fine in a basket. Even the drapery beneath and behind the floral arrangement has an impact on the statement the composition makes. Follow this step-by-step rendering which illustrates these points.

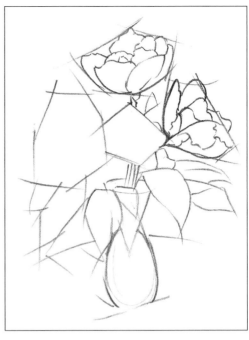

Step One Block in the magnolias and large leaves to form a triangle, which mirrors the cone-shaped top of the vase.

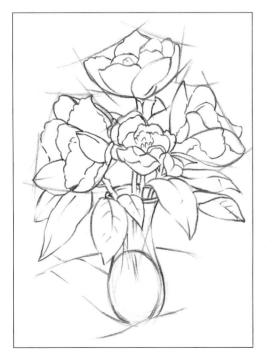

Step Two Refine the lines, letting the curve of the leaves lead the eye down to the vase and then up the stems to the flowers.

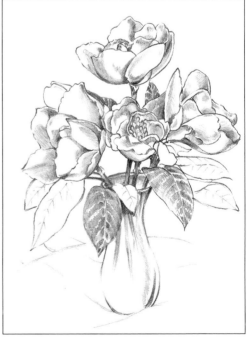

Step Three Begin shading and concentrate on value changes in each segment as shapes overlap to create depth.

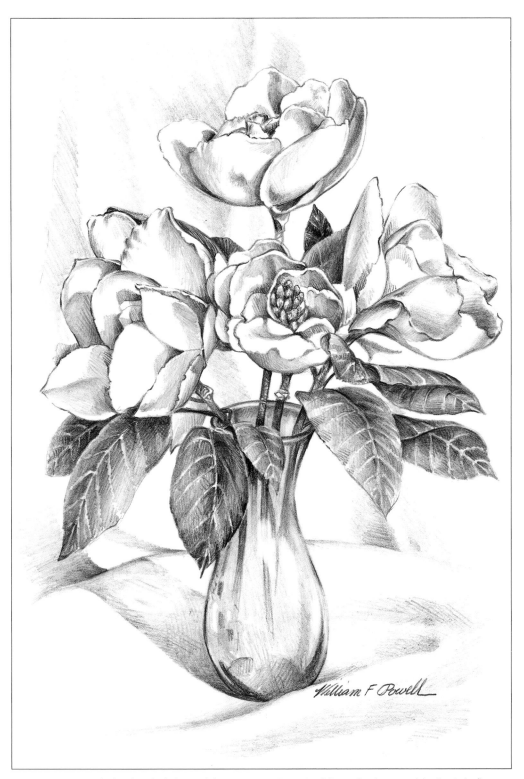

Step Four Continue shading the individual parts of the entire composition, using delicate value changes and detailing in the flowers, leaves, and vase. Add the background and tablecloth, using cast shadows and the values in the folds to enhance the composition.

PLACING PEOPLE IN A COMPOSITION

The positioning and size of a person on the picture plane is of utmost importance to the composition. The open or "negative" space around the portrait subject generally should be larger than the area occupied by the subject, providing a sort of personal space surrounding them. Whether you are drawing only the face, a head-and-shoulders portrait, or a complete figure, thoughtful positioning will establish a pleasing composition with proper balance. Practice drawing thumbnail sketches of people to study the importance of size and positioning.

Basics of Portraiture

Correct placement on the picture plane is key to a good portrait, and the eyes of the subject are the key to placement. The eyes catch the viewer's attention first, so they should not be placed on either the horizontal or vertical center line of the picture plane; preferably, the eyes should be placed above the center line. Avoid drawing too near the sides, top, or bottom of the picture plane, as this gives an uneasy feeling of imbalance.

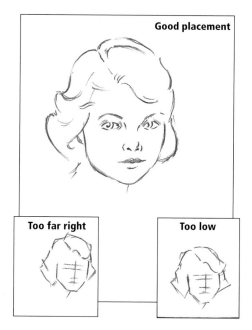

Good placement

Too far right　　**Too low**

Placement of a Portrait The smaller thumbnails here show the girl's head placed too far to the side and too low in the picture plane, suggesting that she might "slide off" the page. The larger sketch shows the face at a comfortable and balanced horizontal and vertical position, which allows room to add an additional element of interest to enhance the composition.

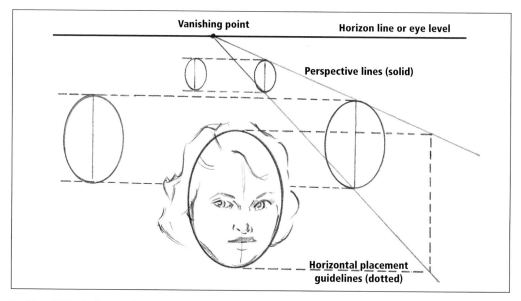

Vanishing point　　　　Horizon line or eye level

Perspective lines (solid)

Horizontal placement guidelines (dotted)

Multiple Subjects If you are drawing several, similarly sized subjects, use the rules of perspective to determine relative size. Draw a vanishing point on a horizon line and a pair of perspective lines. Receding guidelines extended from the perspective lines will indicate the top of the head and chin of faces throughout the composition. The heads become smaller as they get farther from the viewer.

Adding Elements to Portraits

Many portraits are drawn without backgrounds to avoid distracting the viewer from the subject. If you do add background elements to portraits, be sure to control the size, shape, and arrangement of elements surrounding the figure. Additions should express the personality or interests of the subject.

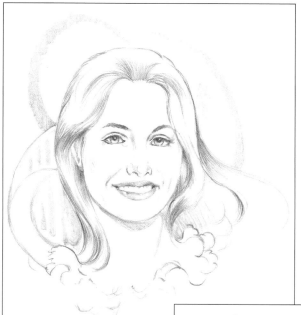

◀ **Repetition of Shapes within the Portrait** The delicate features of this young woman are emphasized by the simple, abstract elements in the background. The flowing curves fill much of the negative space, while accenting the elegance of the woman's hair and features. Simplicity of form is important in this composition;. the portrait highlights only her head and neck. Notice that her eyes meet the eyes of the viewer—a dramatic and compelling feature.

▶ **Depicting the Subject's Interest** This portrait of a young man includes a background that shows his interest in rocketry. The straight lines in the background contrast the rounded shapes of the human form. Although the background detail is complex, it visually recedes and serves to balance the man's weight. The focus remains on the man, but we've generated visual interest by adding elements to the composition.

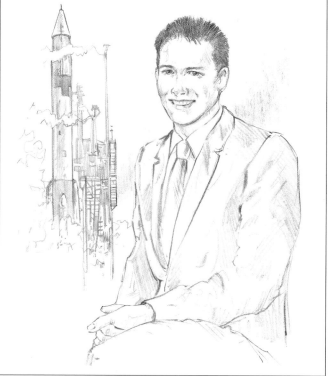

Artist's Tip

Using a photo of a friend or relative, experiment with adding varied backgrounds. See how each choice can change the mood and appearance of that portrait.

Adding Complete Figures

Creating a composition that shows a complete person can be challenging. A standing figure is much taller than it is wide, so the figure should be positioned so that its action relates naturally to the eye level of the viewer and the horizon line.

To place more than one figure on the picture plane, use perspective as we did with the portrait heads. Remember that people appear smaller and less distinct when they are more distant. For comfortable placement of people in a composition, they should be on the same eye level as the viewer with the horizon line about waist high.

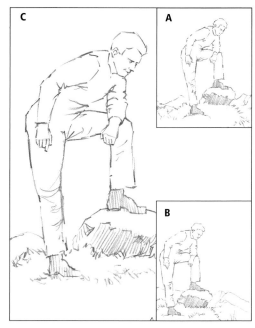

▶ **Full Figure Placement** In thumbnail A, the subject is too perfectly centered in the picture plane. In thumbnail B, the figure is placed too far to the left. Thumbnail C is an example of effective placement of a human figure in a composition.

◀ **Sizing Multiple Figures** For realistic compositions, we need to keep figures in proportion. All the figures here are in proportion; we use perspective to determine the height of each figure. Start by drawing a horizon line and placing a vanishing point on it. Then draw your main character (on the right here) to which all others will be proportional. Add light perspective lines from the top and bottom of the figure to the vanishing point to determine the height of other figures. If we want figures on the other side of the vanishing point, we draw horizontal placement guidelines from the perspective lines to determine his height, and then add perspective lines on that side.

▶ **Line of Sight** Figures in a composition like this one can relate to each other or to objects within the scene through line of sight (shown here as dotted lines). You can show line of sight with the eyes, but also by using head position and even a pointing hand. These indications can guide the viewer to a particular point of interest in the composition. Though the man on the left is facing forward, his eyes are looking to our right. The viewer's eye follows the line of sight of those within the drawing and is guided around the picture plane as the people interact. The man at the top is looking straight up.

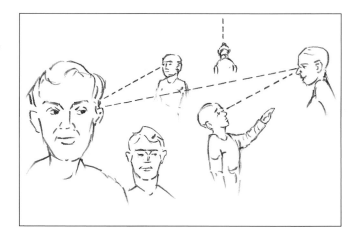

Placement of Single and Grouped Figures

Artists often use the external shape and mass of figures to assist in placing elements within a composition—individual figures form various geometric shapes based on their pose and several figures in close proximity form one mass. Establish a concept of what you want to show in your composition, and make thumbnail studies before attempting the final drawing. The following exercise is based on using the shape and mass of single and grouped figures to create the drawing at the bottom of the page.

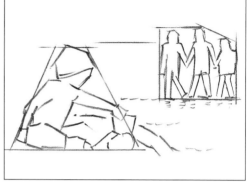

Step One Begin by considering the overall setting—foreground, middle ground, and background—for a subject like these children at the beach. You can use elements from different photos and place them in one setting. Block in the basic shapes of your subjects; the boy in the foreground is a clipped triangular shape, and the group of children forms a rough rectangle. Determine balanced placement of the two masses of people.

Step Two Next, sketch in outlines of the figures. The little boy with the shovel and pail occupies an area close to the viewer. The three children occupy a slightly smaller mass in the middle ground at the water's edge. Even though there are three children in this area, they balance the little boy through size and placement at the opposite corner. The wave and water line unite the composition and lead the eye between the two masses.

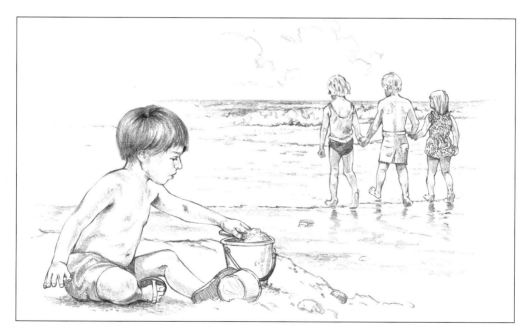

Step Three Place your figures so that they fit comfortably on the picture plane. Add detail and shading to elements that are important in the composition. Use an element in the foreground to help direct the viewer's eye to other areas, such as the outstretched arm of the boy. Placing the small rock between the middle- and foreground creates a visual stepping stone to the three children at right.

COMPOSING LANDSCAPES

When you are composing a landscape, consider the elements you want to include and adjust their size, placement, values, and lines to create a pleasing and balanced composition. The following examples show the relationship of basic elements to one another and to the picture plane in a landscape. The lines could represent trees, buildings, flowers, or other elements in a composition.

 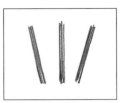

Too Uniform When objects are all uniform, centered on the picture plane, and absolutely balanced, the composition can be monotonous.

Some Interest Angling the object in the center creates interest, but this design is still too uniform; it doesn't lead the eye through the composition.

Too Much Opposition These elements have balanced placement, but the outward angle of the side elements gives an unsettling feeling.

Unsteadiness Although this arrangement is secure and balanced, it still imparts a feeling of unsteadiness. Less severe angles might help.

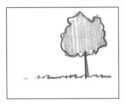 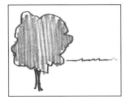 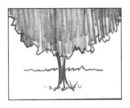

Unbalanced The tree is not balanced by any other object on the picture plane, which makes it seem uninteresting and isolated.

Uncomfortable The tree is the sole focus. It is too far forward and too far to the left for a balanced placement.

Overpowering The tree overwhelms the picture plane, dividing it in half. There's nowhere for the viewer's eye to move.

Comfortable The tree at right is partially out of the picture plane. Its leaves lead the viewer's eye to the small tree.

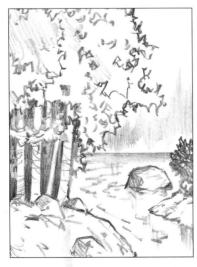 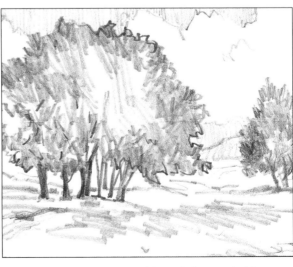

Balanced Mass The foreground trees are balanced by the rock, land, and bush to the right, with the lake and background trees for support.

Repetition for Unity The shape of the stand of trees on the left is repeated by the more distant grouping on the right. The curve of the clouds echoes the tree shapes and hills, which also helps to unify the composition.

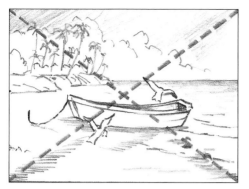

X-Shaped Composition In the drawings at left and below, notice the division of background, middle ground, and foreground. Elements and values are placed within the picture plane in an X shape. Distant palms angle downward toward the boat and the seagulls are moving toward the upper right. Variations in shading create the feeling of depth in the scene. Placing the boat horizontally in the foreground just below and to the right of the X-marked center of the picture plane holds the eye, identifying the boat as the main focal point.

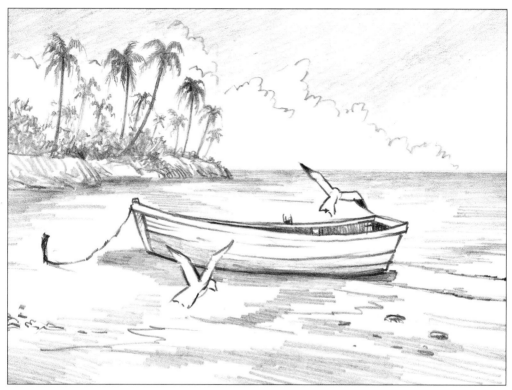

Variation of Focal Element Draw the scene above, substituting each of the boats shown below. Changing the focal element will alter the composition dramatically, leading the eye to different areas of the drawing.

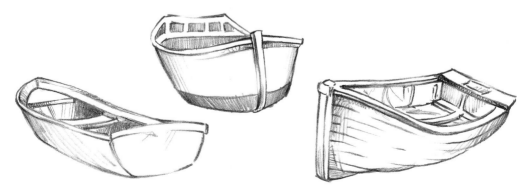

Panoramic Landscapes

This exercise demonstrates how to develop a composition on a wide picture plane, as shown in the thumbnail sketch below. Balance is achieved by placing elements on both sides of the picture plane. The barn is the main focal point and is balanced by the large cloud and trees on the left. The foreground pond balances the cloud area, and the stream leads you into the scene. Try the same wide layout using a desert scene or seascape; all are well suited to the panoramic format.

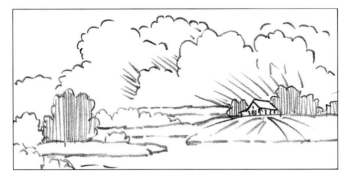

◀ Thumbnail Compositional Plan
Before beginning any drawing, it's a good idea to map out the placement of elements and value indications on a small, compositional sketch. That's especially true for a panoramic composition like this one, because the format is much more demanding than the typical rectangle. The thumbnail helps you get a feeling for the composition and make necessary additions or adjustments before starting your final drawing.

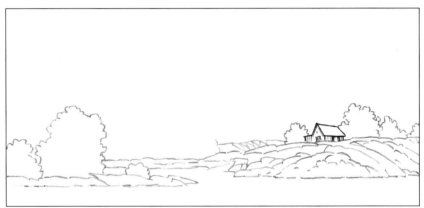

Step One Begin your drawing by establishing the middle-ground landmass, which unifies the composition. Then place the barn and distant trees on the right and the larger, closer trees on the left.

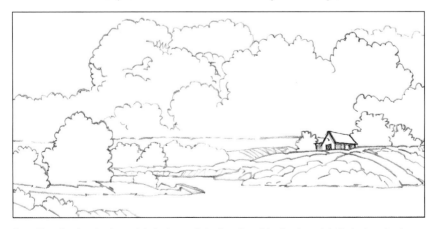

Step Two Develop the shape of the background clouds and small bank at lower left. Notice how the shapes of the clouds repeat the shapes of the tree foliage, which are contrasted by the linear ground elements.

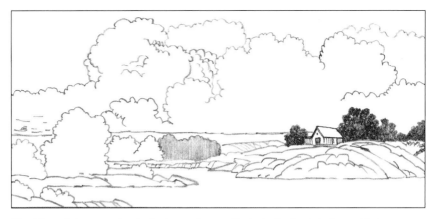

Step Three Refer to your thumbnail value notations, and begin shading the darkest area of the trees near the barn. Notice how the most intense values direct the viewer's eye to the main focal point—the barn—even though it is very small in comparison with the panoramic picture plane.

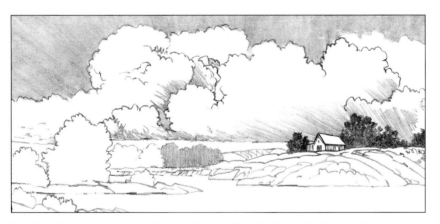

Step Four To draw even more attention to the barn, the lines of shading in the clouds and sky, as well as the lines on the ground, radiate from the barn. Directional shading is especially useful in extremely horizontal compositions, as your eye has to travel a long distance to reach the focal point.

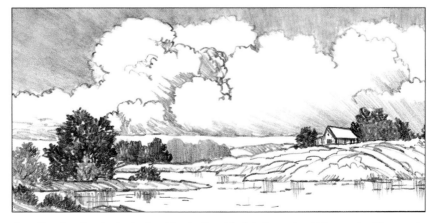

Step Five Complete the drawing by adding details and final shading to the middle ground and foreground. Adjust values until the composition is balanced and the viewer's eye moves throughout the entire panorama.

Vertical Landscapes

Vertical compositions can be daunting, but with careful planning, a good flow and visual drama can be developed. Every space doesn't need to be filled; open areas can actually balance out more intricate parts of the composition and give the viewer's eye a place to rest.

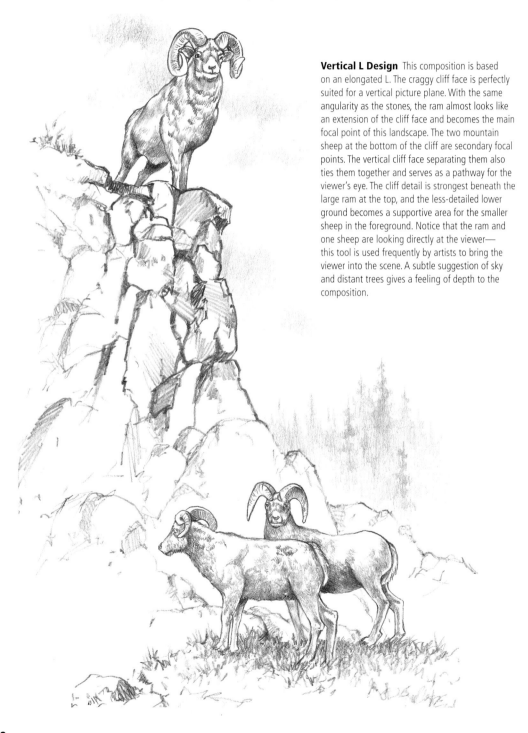

Vertical L Design This composition is based on an elongated L. The craggy cliff face is perfectly suited for a vertical picture plane. With the same angularity as the stones, the ram almost looks like an extension of the cliff face and becomes the main focal point of this landscape. The two mountain sheep at the bottom of the cliff are secondary focal points. The vertical cliff face separating them also ties them together and serves as a pathway for the viewer's eye. The cliff detail is strongest beneath the large ram at the top, and the less-detailed lower ground becomes a supportive area for the smaller sheep in the foreground. Notice that the ram and one sheep are looking directly at the viewer—this tool is used frequently by artists to bring the viewer into the scene. A subtle suggestion of sky and distant trees gives a feeling of depth to the composition.

Depth and Significance of Landscape Elements

When developing a sense of depth in your compositions, remember what attracts the viewer's eye. Larger elements and those that overlap others demand attention and come to the foreground. Also, extensive detail and darker values will draw attention to even a small element. Consider these principles in your landscape compositions. Look for them in the landscapes on the previous pages and below.

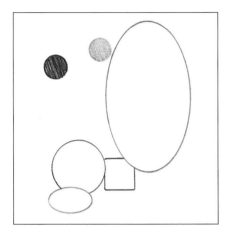

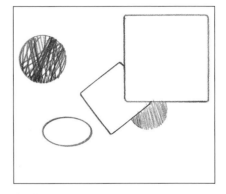

Commanding Attention Notice that the very large oval occupies as much space as all the other elements in this sketch combined and is therefore very important; but the shaded circles, which are a fraction of the oval's size, vie for the viewer's attention. The outlined shapes at the bottom draw our eye last, but their overlapping edges do give a feeling of some depth.

Focal Points The complexity of the underlapping placement and shading on the partially hidden circle compels the eye to look at it, even though it is smaller than most of the other elements. However, the dark circle with interior lines (showing detail) is still the strongest focal point, and the viewer's gaze will be repeatedly drawn to that spot.

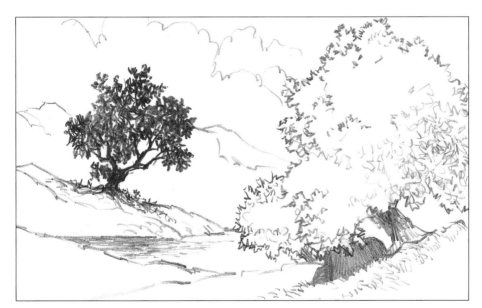

Attracting the Viewer's Eye As shown in the "Focal Points" thumbnail sketch (above right), the darker values of the shaded rock beneath the tree attract the viewer's eye, even though it is smaller than the rest of the elements. By drawing the foreground tree so that it overlaps the small rock, a sense of depth and dimension is produced (as illustrated in the thumbnail where the two squares overlap the small shaded circle). The dark background tree attracts the most attention, as seen in the same thumbnail, because it so strongly contrasts the light values of the foreground tree.

COMPOSING ANIMAL SCENES

Thoughtful planning of size and placement is almost as important as your choice of animal subject to ensure the success of the statement you wish to make. Animals usually are portrayed in "classic" or natural poses for the kind or breed; breaks from that norm are considered either funny or worrisome. Backgrounds should be minimal or include just a few habitat clues to place the focus on the animals. Multiple photographic references often are the best way to capture the animal pose you want to draw.

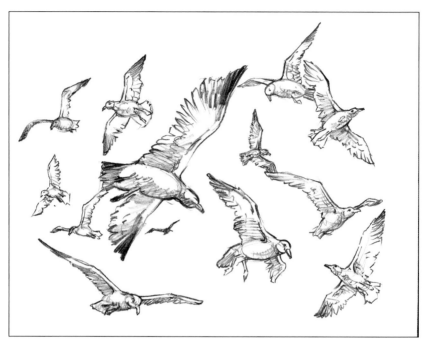

Groups of Animals Seagulls feeding in flight provide an interesting subject. The statement of this composition is their fluid movements while showing the flurry of activity in their search for morsels of food. The X- and O-composition methods shown below were combined to create this drawing, which was assembled from several photos. Slight overlapping adds to the action and creates depth.

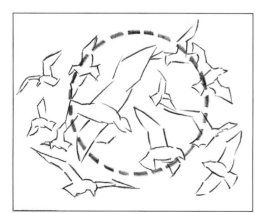

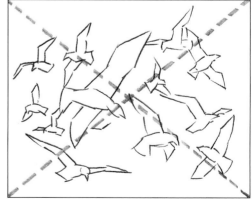

Building the Composition Start with the O-composition method as a guide to show the flight pattern of the birds. Avoid placing the gulls in a perfect circle, as this looks unnatural.

Balancing the Composition By overlaying the X composition, more balance is added. Escape monotony by using the X only as a guide and not placing the gulls directly on the lines.

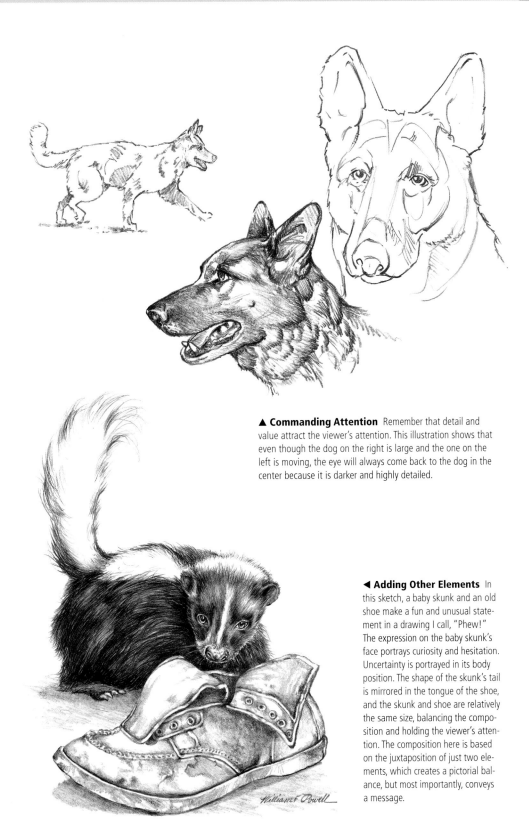

▲ **Commanding Attention** Remember that detail and value attract the viewer's attention. This illustration shows that even though the dog on the right is large and the one on the left is moving, the eye will always come back to the dog in the center because it is darker and highly detailed.

◄ **Adding Other Elements** In this sketch, a baby skunk and an old shoe make a fun and unusual statement in a drawing I call, "Phew!" The expression on the baby skunk's face portrays curiosity and hesitation. Uncertainty is portrayed in its body position. The shape of the skunk's tail is mirrored in the tongue of the shoe, and the skunk and shoe are relatively the same size, balancing the composition and holding the viewer's attention. The composition here is based on the juxtaposition of just two elements, which creates a pictorial balance, but most importantly, conveys a message.

LIGHTING EFFECTS

Light—whether natural or created by artificial means—creates effects that greatly affect a composition. We need to consider the shadows and highlights created by light as elements themselves. Here are a few guidelines and examples that can be helpful in understanding lighting and its influence on compositions.

Basics of Light and Shadow

The light source can be natural (sunlight) or artificial (such as studio or indoor incandescent lighting). Look at your composition from different angles and elevations to see how the positioning of the light and the viewer affects the elements. Viewer attention is drawn toward light areas, whereas shadows are seen as negative spaces (see page 46). We must depict three important factors when showing the effect of light: *Cast shadows*, those thrown by the subject blocking the light source; *core shadows*, the darkest areas on the object itself; and *bounce light*, reflected light within shadows that affect values on all elements and their cast shadows.

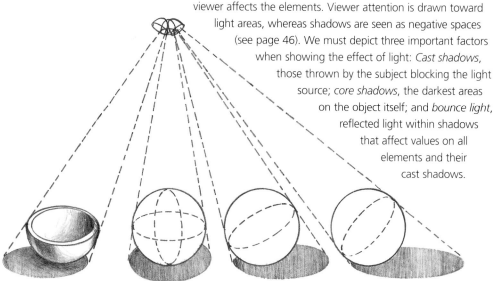

Light and Shadow As you see here, shifting the position of the element or the light changes the shape and direction of the cast shadow. The half sphere at left demonstrates how interior and exterior surfaces catch the light and cast their shadows differently.

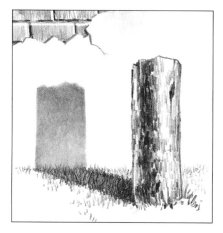

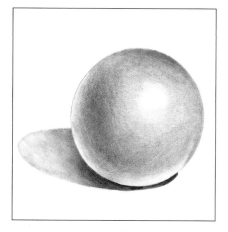

Cast Shadows The post blocks the light (from the viewer's right) and casts a shadow on the ground and wall. The shadow adds to the depth of the composition, leads the viewer's eye to the brickwork, and helps balance the composition.

Core Shadows and Bounce Light The light is directed at the highlight on this sphere and then dissipates into the core shadows. The bounce light shows at the bottom of the ball and in its cast shadow. Value placement gives the composition depth.

Shadows as Elements

Even transparent objects cast shadows and reflect light. For instance, the lights and darks within a glass of water and its shadow are varied but very similar in value. Some values are the result of light being reflected back to the eye, whereas others are light being "absorbed" (or appearing dark) in specific areas. One of the most important rules for depicting clear elements is to draw as few lines as possible, subtly creating the illusion of form through the effective use of values.

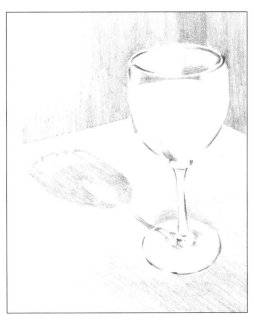

Transparent Objects This photo of a glass of water under simple lighting (from the viewer's right) shows the object, its shadows, and its captured light, as well as how they all contribute to the composition.

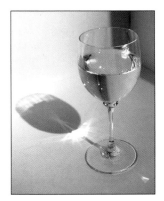

Step One Begin by lightly shading the darkest values in the composition. The glass is formed by drawing only the areas that do not reflect the light: under the rim, stem, and foot and edges of the glass that are vertical to the picture plane. The shadow includes the highlights and shape of the water within the glass. A steep angle is formed by the glass and its shadow.

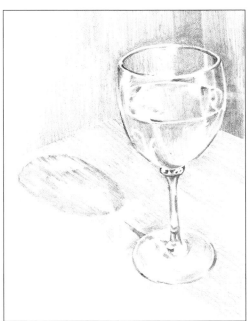

Step Two Continue building the dark areas. The white of the paper creates brightly highlighted areas. Notice how the angles of the background oppose the angles of the glass and its shadow and focus the viewer's attention back on the subject.

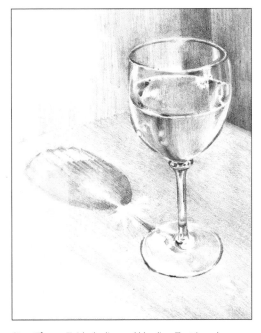

Step Three Finish shading and blending. The triangular composition starts the viewer's eye at the focal point (glass) where the corners of the background meet and then moves down to the shadow, along the wall, and back to the glass.

USING NEGATIVE SPACE

Negative space is the area of a composition that is around or between the focal elements. Often this negative space is as important to the composition as the focal elements, providing balance and unity. Observing and drawing the details within the negative space—even before completing the other elements—is an important technique in creating a realistic composition. The negative space supports the focal elements by offering both repetition and contrast in line, values, textures, and shapes to heighten interest in the composition.

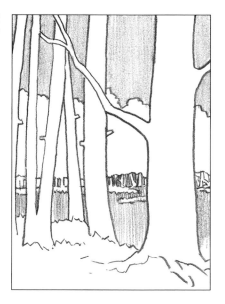

▶ **Blocking in Negative Spaces** In this sketch, everything between the foreground trees is negative space. Use light guidelines to define the large tree trunks. For interest, contrast those strong verticals with the horizontals that form the sky, foliage, and open middle ground, creating a pleasing composition. Begin to add the shading within those negative spaces.

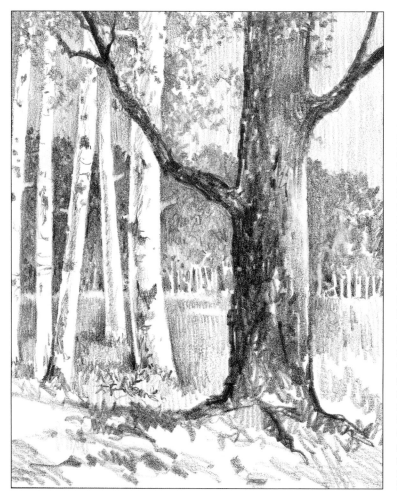

◀ **Adding Details for a Balanced Composition** Now we add details within the negative shapes to give the composition depth, contrast, and balance. Notice that the white-barked birch trees are defined by the darks in the negative space around them; their area is balanced by that darker area of foliage behind them. The deeply shaded, heavily textured tree in the foreground is balanced by the lighter, smoother area of the sky; the value of the vertical dark strokes on the tree should be highly controlled to create an element of major importance without causing the eye to struggle to see the rest of the scene. Foreground grass strokes and details should be soft and supportive to the scene without catching the eye and disrupting the carefully balanced composition.

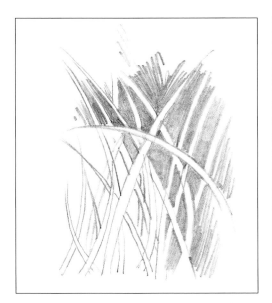

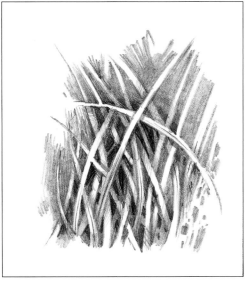

Delineating Contrasts If we lightly draw guidelines for some blades of overlapping grass, and then shade the middle values in the negative spaces, we define those grasses. This composition repeats the actively opposing elements of the grasses, contrasting them with the rectangular negative spaces.

Developing Complexity and Unity Intricacy is developed in the composition by working darker values into the negative spaces, as well as by shading the grasses. The composition becomes more interesting through the negative space, which unifies the grass into one mass.

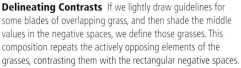

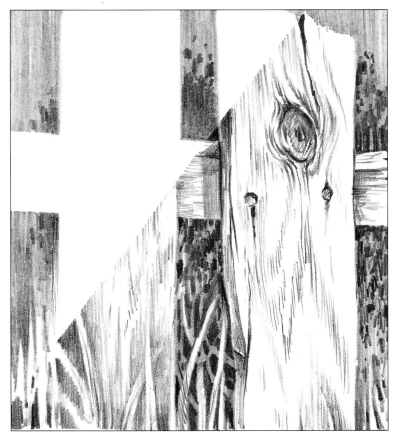

◀ **Creating Depth and Repetition** At the upper left of this sketch, the shape of the old wooden fence is created by drawing objects in the negative spaces around it; dark and light value patterns suggest distant sky and foliage. As the drawing progresses to the right, the white boards are shaded to create texture and shadows. Within the positive space, the knot, nails, grain, and even splits in the wood are repetitions of shapes and values seen in the negative spaces and foreground grasses. Within the negative space, patterns of secondary negative shapes develop as more darks are added to convey depth (such as the space between blades of grass.) The single horizontal board and sky help contrast the mainly vertical elements while offering clear indications of depth. The overall composition is simple, familiar, and comfortable for the viewer.

COMPOSING FROM PHOTOGRAPHS

Photos are great references for creating composi-
tions. Use one photo or take elements from a
number of photos and combine them in one com-
position. Create several different compositions
from one photo; just crop the photo in a way
that emphasizes the main elements and makes a
statement about them. If there is an interesting
element outside the selected area, it can be
moved to a comfortable position within the
scene. Unneeded elements can be eliminated.
Use "artistic license" (the artist's perogative to
ignore or change reality) to add detail. When
composing a scene from photos, look for the
qualities that make a dynamic composition:
depth through shadows and overlapping, asym-
metrical placement, rhythm and flow, value con-
trasts, interesting lines and textures, and balance.

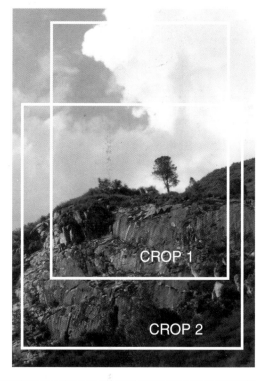

▶ **Shifting Focal Points** In crop 1 at right, much of the
vertical cliff face is cut away; the lone tree is the central focal
point, and the clouds and cliff rocks are balanced secondary
elements. In crop 2, the cliff face becomes a much stronger
element, drawing the eye first, then leading up to the tree.

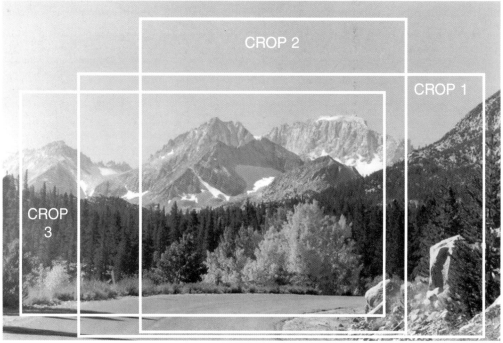

Three Crops from One Photo The trees, mountains, and sky shown here provide the source for three different compositions.
Each crop accents an important part of the scene. Lay strips of paper around each crop to isolate it and study the differences.

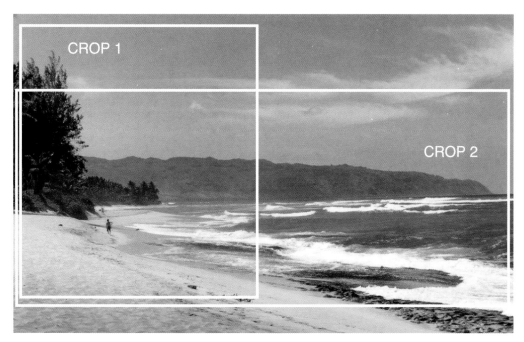

Vertical and Horizontal Crops This beautiful beach scene in Hawaii is an example of how two very different compositions can come from one photo. The vertical crop (1) accents the lone person with the open sky and foreground beach. The horizontal crop (2)—my favorite—accents the long expanse of land and sea and makes the individual on the beach appear much smaller and isolated.

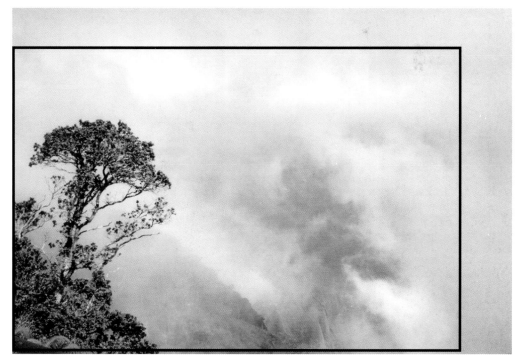

Maximize the Crop This photo, taken on Kauai, shows the mysterious afternoon clouds that float into the canyons. The single crop removes featureless cloud areas and focuses the viewer's eye on the foreground tree against the dramatic cloud formation.

ENLARGING A REFERENCE

Often, your reference photograph or sketch will be much smaller than the surface you have chosen to draw it on. You easily can enlarge or reduce an entire scene or a cropped segment of it to solve this issue. The following exercise demonstrates how to set up a proportional drawing surface when using all or part of an original photo, sketch, or other source material.

Step One Select a drawing surface that is compatible with your chosen subject. The paper should be at least as large as you want your finished drawing to be.

Step Two Place the source material (e.g., the photograph) on the drawing surface in the lower right corner. Don't be concerned if the proportions of the drawing surface and the source material are different, as you easily can adjust it later.

Step Three: To use the entire reference, draw a line from the lower right corner of the reference through its upper left corner. Continue the line until it meets the left edge of the drawing surface. Draw a horizontal line at that point to show the proportional ratio between the reference and the paper. You can trim off that portion of the drawing surface or adjust the final composition by adding to the sky or foreground to fill the entire surface.

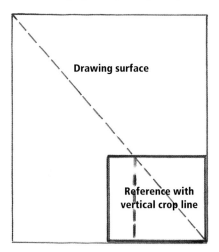

Alternate To fill the entire drawing surface and eliminate subject matter from the reference, draw a guideline from the lower right to the upper left corner of the drawing surface. This line crosses the top edge of the reference, showing how much is in true proportion to the final surface. Drop a vertical line from the diagonal at that point to see how much space to eliminate from the original source material. If necessary, delete space from each side, keeping the important elements.

Using the Grid Method

Sometimes you need help in faithfully transferring the elements of your photo to your composition. For centuries, artists have used the "grid method" of creating proportional enlargement, reduction, or same-size transfer of an entire composition or a selected element. To use this simple technique, first draw a grid of squares over the original image, or use a gridded transparency overlay; then draw a grid of the same number of squares on your drawing surface. Finish by drawing the elements in each square of the original on the drawing paper, one square at a time. The size of the drawing depends on whether the size of the squares has been enlarged, reduced, or has stayed the same.

Enlarging an Image To enlarge a previously drawn image, draw a grid of squares over the image (A). Then create a larger grid of the same proportion—four full squares wide by five full squares high (B). Focus drawing in one square at a time, copying the lines within that square. When all squares are complete, the flower is drawn in exact proportion to the original. Now the grid drawn for the final composition can be erased.

A

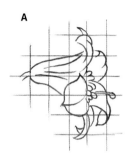

B

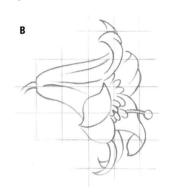

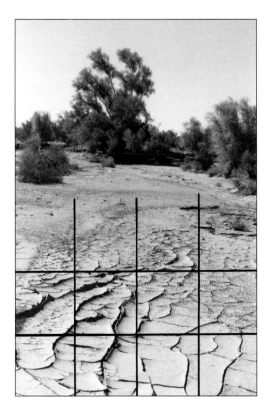

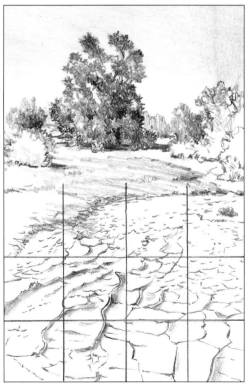

Gridding Complex Subject This original photo shows a grid applied to the complicated lines of the cracked mud. You can add more squares, if needed, to divide the original into a less complicated, easily reproduced image.

Transferring a Same-Size Subject The complex subject is much simpler to replicate when you copy the lines one square at a time. The finished drawing shows how the same-size squares accurately imitate the original photo.

MOVEMENT AND DEPTH

Creating the illusion of movement and depth in a drawing is an essential component of producing a successful composition. These examples show some simple techniques for creating the appearance of action and dimension.

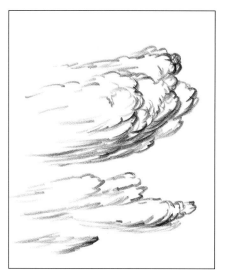

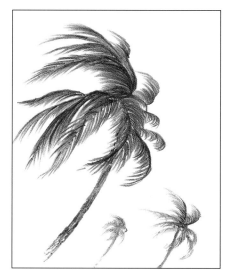

Sweeping Strokes The use of lines that taper away from the direction of movement suggest motion. Notice how the clouds appear to be moving swiftly to the right as if pushed by a fast-moving storm. The strokes are made from right to left.

Directional Forms By controlling the thickness, value, and direction of the lines that form the repeated shape of these palms, we create a feeling of resisting the wind. The position, size, and lighter value of the smaller palms add to the illusion.

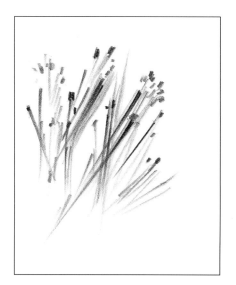

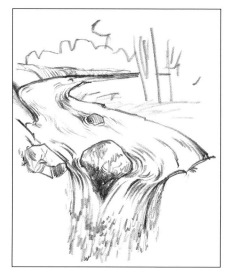

Straight Lines Here straight lines, formed in quick strokes, suggest fast-moving fireworks or a stand of long-stemmed plants swaying in the breeze. The lines are thicker at the top with the value fading at the bottom to suggest distance, and the lines overlap at angles for depth. Dots at the tops of the lines give a feeling of upward movement toward a point of interest.

Flowing Lines The S curve of this stream pulls the viewer along with it. Rocks placed at strategic points serve two purposes: to keep the eye from traveling back too quickly and to show that the water is moving swiftly around them, toward the viewer. The small, uneven, U-shaped strokes placed deliberately in the foreground suggest that water is falling downward.

Fooling the Eye

Within the borders of the picture plane, we can create the illusion of depth and movement by using elements to direct the eye. Line intersection, overlapping, and contrasting values heighten the effect.

Lacking Depth These two-dimensional arrows show that there is no depth, only a single plane with vertical and horizontal elements. Everything appears to be on the same, flat plane. The horizontal line represents an imaginary horizon, but even that fails to give depth because it isn't supported by anything else.

Introducing Some Depth Simply changing the angle of the vertical arrow below the horizon introduces some depth. The ground plane seems to recede into the distance toward the horizon. The arrows in the upper area remain in a two-dimensional plane.

Increasing Depth By adding another plane and making the right vertical smaller than the left, we introduce more depth. This plane appears to be receding into the scene toward the right. The direction of movement in the ground plane has changed, and the upper plane remains flat.

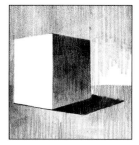

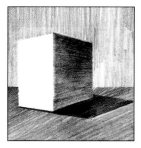

Geometric Depth Three planes—each oriented in a different direction—have been combined here to create a geometric form that appears to have volume, depth, and solidity, even though it consists only of carefully placed lines.

Developing Form in Space The illusion of form is strengthened by the use of values and shadows, which have been hatched in vertically. The low viewpoint gives the composition yet another dimension.

Shading to Emphasize Depth Shading strokes that follow the direction of the receding plane give even more depth. Vertical shading on the wall helps keep the eye within the composition.

Directional Depth with Lines The arrows on the drawing at right show the different directions of movement created in a single composition. Most of the arrows move in two directions; some move up, down, and even around the elements. This movement keeps the viewer's eye flowing around the composition to take in all the elements of the scene.

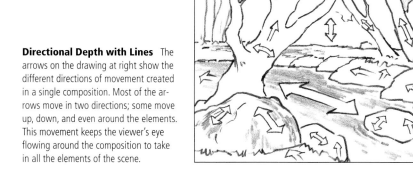

CREATING ATMOSPHERIC DEPTH

Atmospheric depth (or *aerial perspective*) is the effect of distance and impurities in the air on our visual perception of objects—as objects get farther away, they lose contrast, color, and detail. Depicting atmospheric depth by using values—black, white, and varying shades of gray in between—can pose a challenge, but the proper application of values is the most efficient way to achieve this illusion. Objects farther away tend to blend together as a middle-to-light value, losing the intense shading and sharp details you would see up close. Textures blur into smoothness in the distance. The examples shown here will help you see how to use value to achieve atmospheric depth.

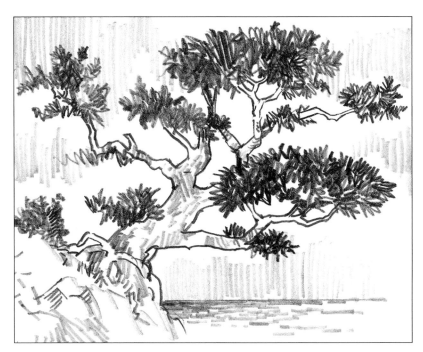

◀ **Value Contrast** The dark values and extensive detailing of the tree bring it forward, so we know that it is closer to us than the lighter water and sky. Softer shading with patterns of light-to-middle values builds a successful backdrop, with the feeling of open sky and subdued, receding clouds. The one exception to the lighter values being farther away is the deep value of the sea beneath the tree, which serves to separate the land and push the tree closer to the viewer.

▶ **Balancing with Values** Here another dark, weathered tree is the focal point. The tree occupies only a small part of the composition, but its dark value and the deep lines of the rocks around it attract our attention. The distant stand of trees at the left, the suggestion of clouds and sky, and the mountain tops all have lighter values indicating their distance, but the amount of space they occupy balances the visual weight of the focal elements.

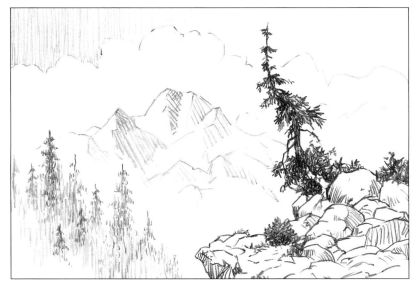

Combining Values with Other Elements for Depth

Value alone seldom creates atmospheric depth in a composition. Value combines with other art elements—like line and texture—to achieve atmospheric effects. Study these examples to see how art elements combine to create the sense of depth that leads the viewer into and around the composition.

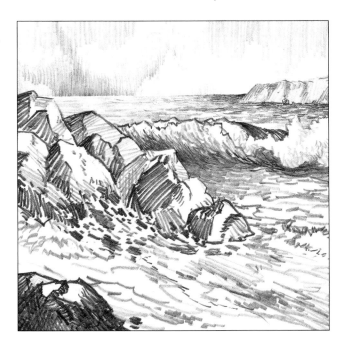

Line Strength and Value Depth The rocks in this seascape are a major part of the statement of this drawing; they are given dramatic weight with value depth, line quality, and direction. Shading in the middleground waves is softer yet strong in stroke direction. The background sky and clouds are formed with lines that are uniform in stroke direction but varied in value; note how they echo the shapes of the waves. The foreground foam and water movement is suggested but not detailed, so it does not detract from the major focal elements. The lines of the rocks, waves, and distant shore lead the viewer's eye out to sea and back again.

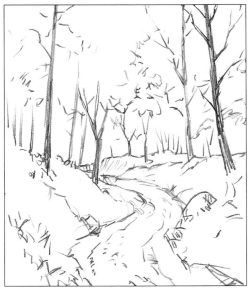

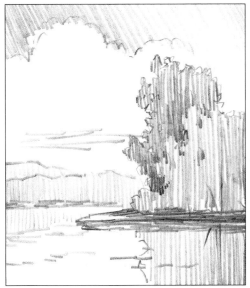

Diminishing Size, Overlapping Shapes, and Shifting Values In this simple line sketch, depth is created through the direction and diminishing size of the meandering path, as well as the overlapping trees and earth mounds. The trees become lighter in value as they get farther away from the viewer.

Strong Linear Shading The soft value of the angled shading in the sky accents the strength of the vertical shading in the middle and foregrounds. This sketch is simple in development, but the attention to value changes and element shapes contribute to the overall success of the composition.

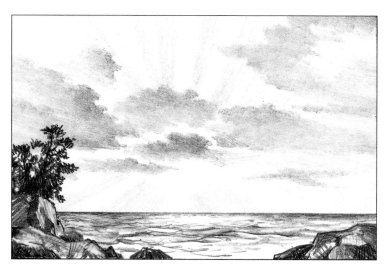

◀ **Radial Lines** The delicate rays of this sunset alternating with streaks of sky create amazing depth in this simple composition. The values in the clouds are strong, heightening their backlit quality, but they are lightly shaded with subtle value changes. The edges of the clouds are indistinct, adding to the illusion of distance. Although the deep values of the tree and shoreline do attract our attention, our eye returns to the dramatic value contrast between the sunlight and clouds.

▶ **Overlapping Shapes** These billowy white clouds are defined by the values of the sky behind them. In a reverse of the drawing above, the clouds are shaded only where they overlap and remain mostly white. Even greater depth in the composition is created by shading the sky around the clouds with middle values. By using only a few mid-range values and shading with strokes that are all made in the same direction, a feeling of calm is produced.

◀ **Limited Detail and Faded Values** This sketch gives the appearance of a misty or foggy atmosphere with its very delicate, soft shading. Only the suggestion of tree trunks, branches, and minimal grass are created with lines. The darker values and greater detail on the right move forward, and the lighter values and limited details on the left recede. The wide expanse of lower sky is shaded very lightly with a long, side-to-side stroke that heightens the atmospheric haziness.

▶ **Value Gradation**
Each composition demands a different set of values to convey the space or depth it occupies. To remind you of the range of values, you may want to include in a particular composition, make a value scale that starts with the lightest value and gradates to the darkest value. Place the scale next to your drawing, and refer to it as a visual guide as you render your composition.

▶ **Range of Values** This composition uses values that are close to those on the scale at the left. In fact, the drawing is light at the top and dark at the bottom, like the value scale itself. In this case, however, the muted tree shapes give the viewer a feeling of atmosphere, possibly the fog or mist of an early morning. As our eye moves up the composition, we see the value of the trees fade. The darker, more distinct trees in the foreground appear closer to the viewer.

◀ **Values in Textures**
This sketch is a study in textures. The swift-moving creek is rushing over the rocks, which are depicted as light and dark value streaks. The mottled rocks are of similar values, except for the dark rock at the lower right, which directs the viewer's eye to the leaves and vine. The details of these textured and patterned elements command the viewer's attention, but they are blended softly so they don't come too far forward in the composition.

▶ **Detailing the Foreground** Although we logically know that the craggy rocks are more textured than the cactus, it is the deeper values in the foreground, combined with the greater detail, that captures our attention. The goal of this composition was to balance the elements while lightening the values and lessening detail in the background to create atmospheric depth. As a result, the small cactus is the focal point, and the magnificent cliffs recede into the background.

USING GEOMETRIC PERSPECTIVE

Geometric perspective is a method of representing a three-dimensional object or scene on a two-dimensional (flat) drawing surface to give the illusion of form, depth, and distance. Perspective also is used to keep all elements in proper proportion as they relate to one another and to their position on the picture plane. The most common methods to acheive this are one-, two-, and three-point perspective. They can be used separately or combined in one composition. In this book, we touch only on some basic points to help us create compositions that are proportionally correct. For an in-depth study of perspective, see my book *Perspective* (AL13) in Walter Foster's Artist's Library series.

One-Point Perspective

In one-point perspective, the top, bottom, and sides of an object are parallel to the sides of the picture plane. The sides of the object recede into the distance toward one point (the "vanishing point") on a horizontal line (the "horizon line"), which represents the viewer's eye level or viewpoint elevation.

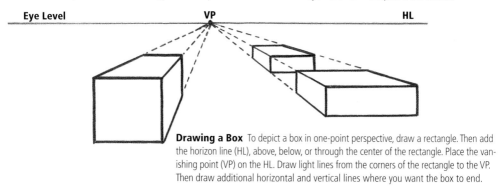

Drawing a Box To depict a box in one-point perspective, draw a rectangle. Then add the horizon line (HL), above, below, or through the center of the rectangle. Place the vanishing point (VP) on the HL. Draw light lines from the corners of the rectangle to the VP. Then draw additional horizontal and vertical lines where you want the box to end.

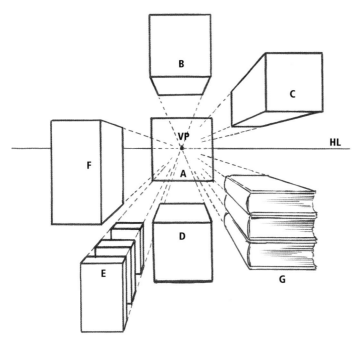

Changing Viewpoints In this example, boxes have been drawn in one-point perspective and placed above, below, and on the horizon line. When the box is on the HL and in front of the VP, we see only the face and none of the sides (A). When the box is above the horizon and directly in front of us, we see the bottom and the face (B). When it is above and to the side of the VP, we see one side, the bottom, and the face (C). When it is below and directly in front of us, we see the top and face (D), and when the box is below and to the side of the VP, we see the top, one side, and the face (E). When the box is on the horizon line and to the side, we see only the face and one side (F). Once you have established the position of the solid box, it can be used as the form for various elements in your compositions. Here the box becomes a stack of books (G).

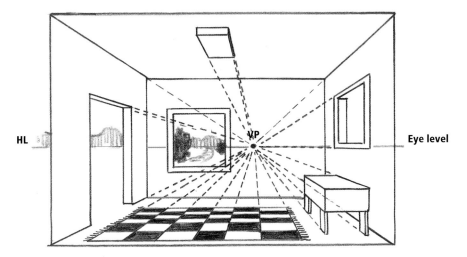

Interior Perspective When drawing an interior scene, the actual horizon may not be visible. However, we use an "eye-level" line in place of the HL as a guide. This exercise uses one-point perspective. Notice that the sides of all the objects recede to the VP. You can see through the door that the actual horizon line is consistent with the interior eye-level line. All objects in this example are positioned so that they are parallel with the picture plane. However, if an object were placed at an angle within this scene, all of its lines would not be parallel to the picture plane, so the objects would need to be drawn in two-point perspective (see page 60).

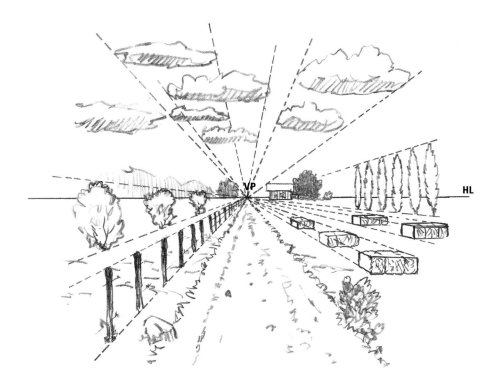

Exterior Perspective This outdoor scene uses the same perspective principles as the interior sketch above. Like any composition, it can be made as complex as you wish, simply by using one vanishing point, with all the objects relating to one another. Cloud forms are not as geometrically shaped as other objects, but they easily can be proportioned using several guidelines and the VP. The fence posts, hay bales, bushes, plowed field rows, and trees all are controlled by this one vanishing point.

Two-Point Perspective

In two-point perspective, the vertical lines are parallel to the sides of the picture plane, but the top, bottom, and sides of the object recede into the distance toward one of two vanishing points on the horizon. We see the corner of a box or other shape, not a rectangular face as in one-point perspective.

Step One Begin by drawing a horizon line. Then draw a vertical line representing the front corner of the box (the corner closest to the viewer). The length of the vertical line is the height the finished box will be.

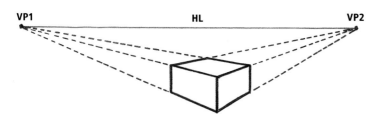

Step Two Select the angles desired for the right and left sides of the box, and draw guidelines from the bottom of the vertical corner line to the horizon line. Mark dots for vanishing points VP1 and VP2 where the guidelines meet the horizon line. Now add guidelines from the top of the vertical line to the VPs. Draw two vertical lines to represent the back corners of the box.

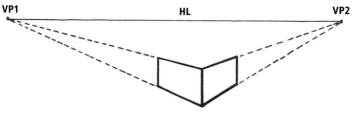

Step Three Draw guidelines from the top left corner of the box to VP2 and from the top right corner to VP1. These lines always should be drawn from the top of the rear vertical of the box to the opposite vanishing point. Where the two lines meet they form the farthest corner of the box, and the box is complete.

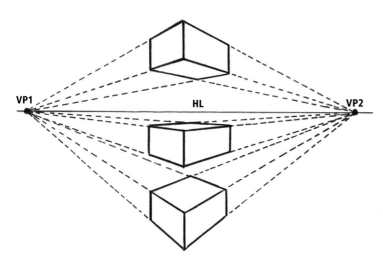

Positioning Subjects As shown in these three boxes, a distinct illusion is created by using two-point perspective. The elevation and depth of the three-dimensional boxes changes with the placement of the original vertical line. Each box uses the same two vanishing points and could be moved right, left, up, or down and redrawn for a different view. Although vanishing points can be placed anywhere on the horizon line, they must be determined by the placement of the bottom of the object's sides at a believable angle and separated by enough distance to avoid distortion.

Ellipses in Perspective

Ellipses are circles that have been drawn in perspective. Ellipses are the basis for many elements for our compositions and can be extended into cylinders to form the tops of cans and vases, tires, knobs, and even food. Ellipses can be drawn realistically using one- or two-point perspective.

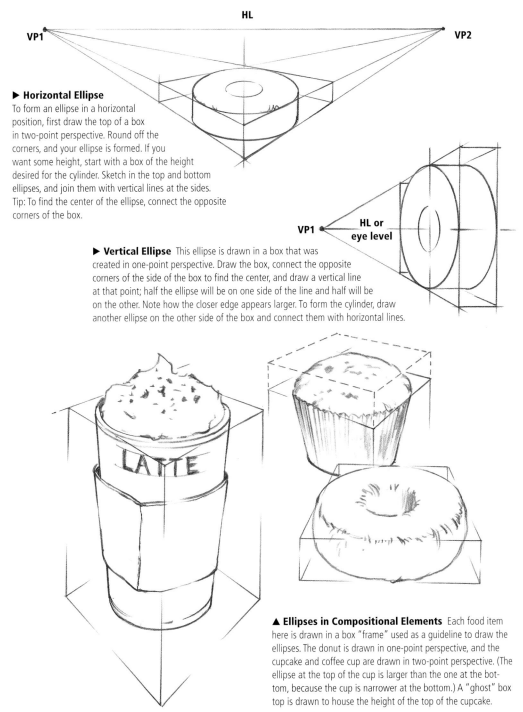

HL

VP1 **VP2**

▶ **Horizontal Ellipse**
To form an ellipse in a horizontal position, first draw the top of a box in two-point perspective. Round off the corners, and your ellipse is formed. If you want some height, start with a box of the height desired for the cylinder. Sketch in the top and bottom ellipses, and join them with vertical lines at the sides. Tip: To find the center of the ellipse, connect the opposite corners of the box.

VP1 **HL or eye level**

▶ **Vertical Ellipse** This ellipse is drawn in a box that was created in one-point perspective. Draw the box, connect the opposite corners of the side of the box to find the center, and draw a vertical line at that point; half the ellipse will be on one side of the line and half will be on the other. Note how the closer edge appears larger. To form the cylinder, draw another ellipse on the other side of the box and connect them with horizontal lines.

▲ **Ellipses in Compositional Elements** Each food item here is drawn in a box "frame" used as a guideline to draw the ellipses. The donut is drawn in one-point perspective, and the cupcake and coffee cup are drawn in two-point perspective. (The ellipse at the top of the cup is larger than the one at the bottom, because the cup is narrower at the bottom.) A "ghost" box top is drawn to house the height of the top of the cupcake.

Three-Point Perspective

In three-point perspective, there are two vanishing points on the horizon (as in two-point perspective), but there also is a third point somewhere above or below the horizon line. Angled lines, such as peaked roofs or verticals of tall buildings, vanish to this third point.

Step One Draw a box using two-point perspective, with the vertical corner (closest to us) extending above and below the horizon line.

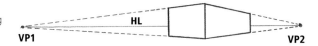

Step Two Draw guidelines from corner to corner of the smaller end plane. The perspective center of the plane is where the guidelines cross. Draw a vertical line, as shown, to be used in placing the peak of the roof.

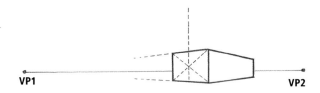

Step Three Lay your ruler on an angle from the front top corner and intersecting the vertical line. Before you draw, adjust the angle to a comfortable pitch for the roof; then draw the line past the vertical. Place a third vanishing point past where the line crosses the vertical. Next draw a line from the back top corner to the third vanishing point (VP3) to establish the angle of the back eave. Now draw a line to VP2 from where the front guideline intersects the vertical. One side of the roof is complete.

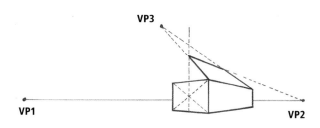

Step Four To complete the roof, draw a line from the top point of the roof to the left top corner of the face plane. The building now has a steeply pitched roof.

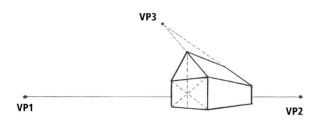

Alternative Placement of VP3 To raise or lower the pitch of the roof, just raise or lower the third vanishing point. Follow the vertical guideline to maintain accuracy without distortion.

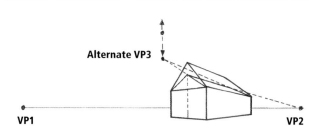

Dramatic Perspective

Three-point perspective is often used for drawing tall buildings seen from a bird's-eye or worm's-eye view, as illustrated in the examples below.

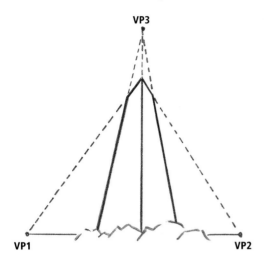

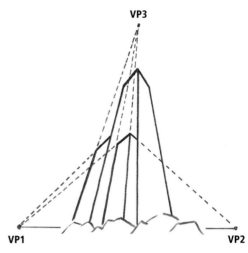

Step One Draw the front vertical corner of a structure from the horizon line to a spot high above it. Place three VPs, two on the horizon line and the third at the end of the vertical. Add the side lines, from VP3, and the top lines to VP1 and VP2.

Step Two Continue to add sections to the building, using VP3 to establish the vertical sides and using VP1 and VP2 to complete the tops of those sides. Adding sections to the building at different heights will make it more complex and interesting.

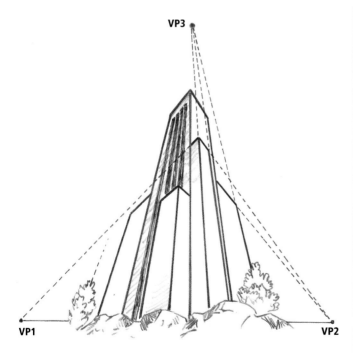

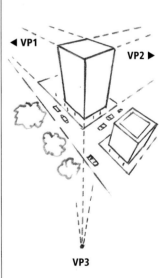

Step Three Complete the composition with trees and other details which also align with the guidelines to the third vanishing point. The horizon line is at a low elevation, which allows for more sky and a very dramatic view of the subject. We are even looking up at the rocks at ground level.

Looking Down with Perspective
This sketch shows a different view of a city in three-point perspective. We are at a very high viewpoint looking down on the scene, so the third vanishing point is actually below street level.

FINAL THOUGHTS

Composition is the basic foundation upon which we build our drawings. We do this by selecting the right combinations of elements and presentation formats. We organize and combine subjects within the picture plane to produce a pleasing and harmonious composition, one that compels the viewer's eye. Many rules that are considered absolute can be bent with a little common sense to produce a visually balanced final presentation. However, it is worth knowing the rules before using artistic license or attempting to work on an unusual picture plane. Most of all, your personal instincts are extremely valuable in deciding when to stray from the tried-and-true principles.

Artists who draw and paint are more fortunate than a sculptor or photographer in that we can move elements around in our composition. We can change their size and shape and place them where we feel they look best to be more harmonious with all the other elements. I hope the various compositional methods presented in this book will be of great assistance to you when creating your own dynamic composition.

William F Powell